MAKERS AND USERS
American Decorative Arts, 1630–1820,
from the Chipstone Collection

Ann Smart Martin

Elvehjem Museum of Art
University of Wisconsin–Madison
1999

The book is published on the occasion of the exhibition *Makers and Users: American Decorative Arts, 1630–1820, from the Chipstone Collection,* organized by Ann Smart Martin and the Elvehjem Museum of Art, University of Wisconsin–Madison from August 21 through October 24, 1999.

Cover illustration: Great Chair, 1640, attributed to John Elderkin, oak, cherry, and ash. Chipstone Foundation 1992.2.

Back cover: Needlework Playing Surface of Charlestown, Massachusetts Card Table, 1755–1775, attributed to Benjamin Frothingham, Jr. Chipstone Foundation 1972.9

ISBN 0–932900–46–1

Library of Congress Cataloging-in-Publication Data

Martin, Ann Smart, 1960–

 Makers and Users: American Decorative Arts, 1630–1820, from the Chipstone Collection / Ann Smart Martin

 p. cm.

Published on the occasion of an exhibition held at the Elvehjem Museum of Art, University of Wisconsin–Madison, Aug. 21–Oct. 24, 1999.

 Includes bibliographical references and index.

 ISBN 0–932900–46–1 (pbk.)

 1. Furniture, Early American Exhibitions. 2. Pottery, English—United States Exhibitions. 3. Prints, American Exhibitions. 4. Prints—17th century—United States Exhibitions. 5. Prints—18th century—United States Exhibitions. 6. Prints—19th century—United States Exhibitions. 7. Furniture—Wisconsin—Milwaukee Exhibitions. 8. Pottery—Wisconsin—Milwaukee Exhibitions. 9. Prints—Wisconsin—Milwaukee Exhibitions. 10. Chipstone Foundation Exhibitions.

I. Elvehjem Museum of Art. II. Title.

NK2406.M369 1999
745'.0973'07477583—dc21 99–382459
 CIP

CONTENTS

DIRECTOR'S FOREWORD

This exhibition celebrates a new partnership between the University of Wisconsin–Madison and the Chipstone Foundation of Milwaukee. The foundation, which was established in 1965 by Stanley and Polly Stone to preserve their collection and to stimulate research and education in the decorative arts, recently endowed a chair at UW–Madison's Department of Art History, the Chipstone Professor of American Decorative Arts. The present exhibition has been organized by this chair's first incumbent, Ann Smart Martin, working with a class of mostly art history students.

The Elvehjem's exhibition presents only a small selection of objects from the Chipstone collection, which consists of furniture, prints, and other decorative arts manufactured and/or used in America from the early seventeenth through the early nineteenth centuries. It is intended to introduce this wonderful resource to the Madison community and to provide evidence of its strong educational potential. It is the first in a series of periodic projects that will explore the understanding of our culture through the decorative arts and promulgate Stanley and Polly Stone's strong belief in an object-based epistemology.

The efforts of Professor Martin and her students, whose names are listed in the curator's acknowledgments, were indeed prodigious to have produced the present exhibition and catalogue in only a single semester. Professor Martin's intellectual leadership and energy were essential to the successful conclusion of such a challenge. Her students industriously participated in all aspects of the project: selecting objects for display, refining the themes, writing labels, preparing brochures and the catalogue, etc. We hope the experience they gained will prove inspirational and useful to their future career goals.

We are very grateful to the Chipstone Foundation, which not only made its collection and archives readily available but also provided generous support in myriad ways. We also want to thank Luke Beckerdite, the former curator of the Chipstone collection, for his guidance and scholarly research.

It also gives me pleasure to acknowledge the generosity of The Evjue Foundation, Inc. /The Capital Times and UW–Madison's Hilldale Trust for sponsoring this exhibition.

The expertise and work of our museum staff are always vital for mounting an exhibition and preparing a catalogue. In this case, they did double duty serving as museum professionals and as teachers working with students in their areas. Assistant director for administration Corinne Magnoni managed the financial aspects of the project; exhibition designer Jerl Richmond worked on the design and installation of the exhibition; curator of education Anne Lambert organized educational components to supplement learning about decorative arts; registrar Pam Richardson handled logistical arrangements; and editor Pat Powell organized and edited the catalogue. For design and production of the catalogue, we are grateful to Earl Madden and University Publications. For the high-quality photographs in the catalogue, we must thank Gavin Ashworth of New York.

Finally, we should express our gratitude to Stanley and Polly Mariner Stone whose commitment to education and the arts, foresight, and extreme generosity made this project and the many projects to come possible. They were truly wonderful people.

Russell Panczenko
Director
Elvehjem Museum of Art
Univeristy of Wisconsin-Madsion

CURATOR'S ACKNOWLEDGMENTS

An exhibition of this breadth coming together in less than a year can only be accomplished with the extraordinary optimism, cooperation, and enthusiasm of many people and institutions. Within days of my arrival on campus last fall to take up my new position as the Chipstone Professor of American Decorative Arts, Russell Panczenko came to me with the idea for this sesquicentennial exhibition from the Chipstone Foundation's collection. Knowing little yet about the specific objects at Chipstone, my first call went to Luke Beckerdite, the foundation's curator and executive director, and, in my mind, the most important person who could make this happen. After Luke and I enumerated all the reasons we could not do this exhibition in such a short time, we determined to make it work. I personally could think of no better way to celebrate new programs in the study of American material culture than to bring some marvels of the Chipstone collection from Milwaukee to Madison.

I wanted the exhibition to be a broad introduction to the collection and to the latest ways early American decorative arts are being studied. I even thought we could challenge some old ways of thinking about these household objects. I came up with a list of broad themes, and Luke and I met at Chipstone on a sunny fall day. The experience is one I shall always remember. With Luke's intimate scholarly knowledge of the Chipstone collection and the depth of his expertise about the American decorative arts, he immediately suggested the furniture that perfectly demonstrated the decorative arts stories we wished to tell. Quite soon he finalized his plans to leave his position as curator at Chipstone, but promised he would follow this exhibition through to its completion. It is to him that my greatest thanks are due. Luke provided detailed descriptions, histories, and themes about every furniture piece, arranged necessary photography, gave comments on my essay, and throughout the search for his replacement and in his absence from Milwaukee, helped in every way. His firm guidance as editor of the journal *American Furniture* for the past six years also has given us many new important studies to ground the stories we wished to tell. Nancy Sazama, administrative coordinator at Chipstone, filled in every gap during the hiatus without a curator on staff, answering continual queries and helping to locate the photographs for the catalogue. After Jonathan Prown was hired as the new director and curator, he stepped in to arrange other important details. The catalogue of Chipstone ceramics written by Leslie Grigsby and nearing publication provided information needed to include the ceramics in the exhibition. Gavin Ashworth made it a priority to complete the excellent photographs for the catalogue in good time.

Early in the fall I had decided to offer a class on exhibition practices in the deco-

rative arts with the opportunity to do practical work to bring the show to fruition. In January my focus shifted to the exhibition class and putting it all together. If I ever doubted the ability of students to rise to any challenge put to them, the ten intrepid students in my course allayed that concern; they will make me forever proud. They were James Bryan, Bolaji Campbell, Catherine Cooney, Robert Cozzolino, Ryan Grover, Diana Sacher, Sherri Shokler, Joann Skrypzak, Gabrielle Warren, and Amy Wendland. While each student contributed to specific tasks, I especially want to thank Joann Skrypzak, who in her position as the Chipstone project assistant became my right hand in managing this task. The students helped refine the themes, selected the prints and ceramics, and wrote the initial label copy, all in about six months. They also performed a thousand duties: researching primary documents and object details, procuring additional visual materials for the exhibition, drafting a family guide, doing original artwork, and helping to coordinate with Elvehjem staff.

If the students performed herculean feats amongst all their competing course work, so too did the Elvehjem staff. Special thanks are due to Pat Powell, Jerl Richmond, Pam Richardson, and Anne Lambert. Other friends and colleagues have helped in multiple ways. Special object expertise was provided by Beverly Gordon (textiles), Clio March (porcelain), and Andrew Stevens (prints). A coterie of colleagues read my frantic efforts to produce a catalogue essay in record time. At the University of Wisconsin–Madison, these included the faculty and graduate students of the Early Americanists Study Group, and colleagues Julia Murray, Gene Phillips, and Gail Geiger in the art history department, and Virginia Boyd in environment, textiles, and design. Others who read the essay included James P. Whittenburg, Jon Prown, and Luke Beckerdite. My husband Carl and daughter Kate patiently went without my time and attention as this task loomed large. My final debt is to Stanley and Polly Stone, who had a remarkable vision for collecting and supporting scholarship in the decorative arts. With the Chipstone Foundation's stewardship of the Stones' legacy, a new academic affiliation between the university and Chipstone has been realized. This exhibition is thus, I hope, a fitting celebration of innovative study and appreciation of American material culture as expressed in the decorative arts.

Ann Smart Martin
Chipstone Professor of American
Decorative Arts
Art History Department
University of Wisconsin–Madison

ARTS, COMMODITIES, AND ARTIFACTS
The American Decorative Arts, 1630–1820

Ann Smart Martin

This exhibition presents an array of American decorative objects from 1630 to 1820 and studies them simultaneously as arts, commodities, and artifacts of daily life. The goal is to tell stories not only of furniture, pottery, and prints but also of the people—makers and users—behind them. During the nearly two centuries covered in the exhibition, the colonies—and then the new nation—underwent remarkable changes in social relations, economic patterns, and cultural ideals, all of which found expression in changing forms of production and consumption. Makers of American furniture borrowed from and transformed mostly British styles to produce attractive, often beautiful, products in a competitive commercial market. A broad cross-section of the American population became more avid consumers, and, at the top, wealthy elites embraced new ideals of refinement that were disseminated from Europe and were conveyed through behavior, objects, and environment. This led to extraordinary changes in the kinds of social practices and objects that constituted everyday life. Nonetheless, although most wealthy Americans keenly followed style and fashion from abroad, the American population was comprised of multiple ethnic groups and lived under differing social conditions. How things were made, looked, and used is part of the evolution of becoming a new nation.

The objects in this exhibition are drawn from the Chipstone collection of early American decorative arts. The collection began with the personal choices of Stanley and Polly Stone, but once a professional curator was hired the Chipstone Foundation expanded their collection and provided support for scholarship in early American material culture. The collection is concentrated on three of the most important forms of American decorative arts, dating from about 1630 to 1820. During this period, European cultural influence and trade relations were strong, so the American decorative arts are defined by what was used here as well as what was made here.

The most significant part of the collection is American furniture, mostly made in New England and the mid-Atlantic regions. England's mercantilist economic policies discouraged colonial competition with home industries or crafts. Yet because transportation costs for furniture were high and raw materials were readily available, most furniture used by Americans was made here. The majority of the examples in the Chipstone collection are fine, highly ornamented products following the styles of Europe, modified and expressed in England, and created in America by immigrant English and European and native-born artisans. Less numerous in this collection but as important are examples of the products of separate ethnic groups or more rural places. Because this furniture was made in America, it permits a closer view of American woodworkers as artists and businessmen and of their roles as interpreters of style and hence culture.

The second focus of the collection is English ceramics. British potters continually competed against their European counterparts. In the seventeenth century their European rivals were often more successful, for example, when German stoneware flooded the English and American market. Within a century the British ceramic industry was the world leader. Against such highly competitive and technologically

advanced industries making easily transportable goods, few American potters could compete in any but the more utilitarian wares. Hence the most stylish and commonly used table and dining wares of the seventeenth and eighteenth centuries were imported. Ceramic technology and style changed according to an increase in potter's skills and varying consumer taste and social practices.

Third, the Chipstone collection contains important examples of English and American prints and needlework. Like many ceramics, prints were at least partially mechanically reproduced in multiple copies. Extremely popular forms of art, they were both decorative and informative. That latter, more directly useful function ultimately allowed American printmakers to compete with their English rivals in the production of American scenes of people and places. Needlework, similarly for display and beauty, was not created by professionals but by young women as part of their domestic training. Ceramics, prints, and needlework then are especially effective evidence of the evolving uses and meanings in the world of goods.

The American decorative arts ultimately tell about the culture that produced and used them. This exhibition examines makers by looking closely at style (how things look), construction (how things are made), and artisans as both artists and businessmen. It then looks at users by examining the popularity of forms and changing social practices. It is difficult to categorize these concepts neatly. An artisan's work was tied to a patron's preference, for instance, and aesthetically pleasing products also had to perform a task. The decorative arts are ample evidence of the complexity of early American life. They also demonstrate two dramatic tensions. While tied to British fashion and style, colonists maintained strong regional preferences, not American ones. Most wished to be part of English culture, while economic, social, and cultural realities pulled them further apart. Coming together and breaking apart is the ultimate story of our national heritage—the process of becoming Americans.

MAKING THE WORLD OF GOODS

In a 1784 treatise entitled "Information to those who would Remove to America," Benjamin Franklin described American society and the type of person who would best fit and prosper in the new nation. He pointed to the lack of extreme disparities of wealth that could be found in Europe: the new nation was characterized by a "happy Mediocrity" of neither too many rich nor too many poor. He saw little need for artists whose work was not practical. Without a class in America that lived idly on rents or incomes, few would pay the high European prices for painting, statues, and architecture—works of art he called more curious than useful. Indeed, those American "natural geniuses," he reported, had moved to Europe for a market for their art. In contrast, Franklin asserted that artisans would find a welcome home. He wrote that "there is a continual Demand for more Artisans of the necessary and useful kinds who supply Cultivators of the Earth with Houses, and with Furniture & Utensils of the grosser Sorts which cannot so well be brought from Europe." Such "tolerably good workmen in any of those mechanic Arts" would find ready employment and be well paid for their work. The wide availability of land siphoned off many industrious individuals to farming and thereby kept wages high and provided a ready market to support the training of young boys as apprentices in the crafts.[1]

Not only would artisans find a market for their work and raise themselves to a happy wealth, but also would receive a measure of respect. A man's status or honor of birth in an esteemed family had a value in Europe, Franklin wrote, "but it is a commodity that cannot be carried to a worse Market than to that of America, where people do not enquire concerning a Stranger, *What is he?* but *What can he do?*" He added, "the People have a Saying, that God Almighty is himself a Mechanic, the greatest in the Universe; and he is respected and admired more for the Variety, Integrity, and Utility of his Handiworks, than for the Antiquity of his family."[2]

Franklin's late eighteenth-century categorization of artists and artisans, art, and art objects fits surprisingly well with modern scholarship. The mechanic arts of Franklin's phrase—such as furniture, pottery, and decorative prints—are now called the decorative arts, but still denote those things useful as well as ornamental. Like Franklin, modern scholars distinguish these household objects from those "Works of Art that are more Curious than useful," such as paintings, sculpture, and architecture, deemed today as "high arts."

Decorative arts objects were made in this period for an evolving commercial market. To be successful, an artisan had to produce an object that pleased an aesthetic, came at an appropriate price, and aided in the performance of a function or task. All three aspects are part of the ideal of value and combine to help us understand the way things look and the way things are made.

Art Objects

Decorative arts objects encode cultural assessments of what is beautiful and stylish—in essence, what is attractive in an appropriate form. Stylistic preference developed within a finely tuned dynamic between external sources and local and individual taste. Because well-to-do Americans wanted to be considered cosmopolitan and fashionable, artisans frequently touted their up-to-date knowledge from England.

Styles from abroad came in three major ways: the importation of particular objects, the influx of artisans trained in particular techniques and styles, and the importation of published design sources. If artisans came from such established style centers as London, the adoption of the latest British styles and techniques was rapid. A London-style, joined-furniture tradition was established in Boston with the arrival of Ralph Mason (by 1635) and Henry Messenger (by 1641). Both men trained sons, grandsons, and apprentices in a tradition that lasted until 1700. These early objects were precisely English in the London style—made by Englishmen for an English taste. They used exotic woods prized for their color and grain, like Spanish cedar and Virginia walnut. They were in the latest style, with elaborate architectural details (including applied spindles and moldings) that show the influence of northern Europe on English design. They incorporated the newer technique of dovetailed construction, rare in New England pieces. Both the chest (figure 1) and the folding table (see catalogue 91) in this exhibition are fine examples of the strong Mason-Messenger tradition established and upheld through family linkages. The products of this Boston shop tradition eventually became a less purely London design.[3] On the other hand, even within Britain, there were regional varieties. In the Chipstone collection is a joined chest (figure 2) made sometime in the last third of the seventeenth century and attributed to the shop of Thomas Dennis of Ipswich, Massachusetts (1638–1700). The carving on the chest is remarkably similar to contemporary Devonshire examples that were painted and had carving picked out in various colors.[4]

Nonetheless, American-made furniture seldom replicates English examples. Colonial conditions alone prevented direct copying as a regular practice. Houses of wealthy Americans, for instance, were rarely the size of great English homes, so American furniture was often of a small scale and size. As important was the relationship of materials and labor. Natural resources in Europe were declining as population was rising. In America, the vast tracts that needed to be cleared meant that wood for fuel and building was readily available. This is clearly demonstrated in the way wood was processed into furniture in the seventeenth-century colonies. Wood stock was usually sawn into appropriate dimensions in England. In seventeenth-century America the stock was more often riven (sawn) from sections of logs with large portions wasted, before being further reduced and shaped with finer tools. Riving was a quick one-man job; sawing required two laborers. Wood was cheap, labor was expensive. The stiles, rails, and panels of the Dennis joined chest show this technique.

Nor did all Americans want to replicate English products. While British influences were the most profound, large numbers of

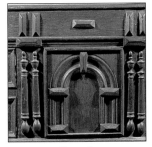

Figure 1.
Detail of Mason-Messinger chest (cat. 15)

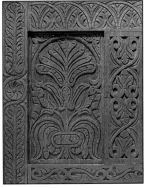

Figure 2.
Detail of Dennis chest (cat. 14)

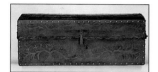

Figure 3.
New York leather trunk (cat. 18)

Figure 4.
Detail of Newport card table
(cat. 21)

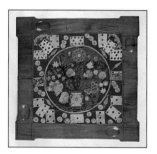

Figure 5.
Detail of Charlestown,
Massachusetts card table
(cat. 20)

Figure 6.
Detail of Philadelphia card table
(cat. 22)

Europeans of different ethnic heritages—especially Germans and French Huguenots fleeing persecution, recruited as good settlers, or simply looking for a better life—led to further cultural blending and influences not experienced in England. Just as in the Moravian settlement depicted in catalogue 18, these groups often clustered themselves together in close-knit communities. This grouping led to strong ethnic preferences, and certain objects have quite distinctive methods of manufacture or motifs. The New York leather trunk (figure 3) in the Chipstone collection is a dovetailed box and lid that has leather embossed with geometric panels, vines, birds, and animals—details commonly found on Dutch, Swiss, and Germanic decorative arts. These ethnic groups often used objects and styles to express their distinctiveness from a larger Anglo-American culture. Hence, their methods of production and styles of furniture changed little.

Stylistic preferences emerged because style is integrally linked to culture and therefore sensitive to social, economic, and political conditions. The varied economic and cultural backgrounds of inhabitants of the New World help explain some ways American furniture and furnishings are different. More subtle aesthetic variations arose from local and regional preferences. In cities, although furniture was closely linked to European styles, its design evolved in subtle, yet distinctive ways. Each city contained many furniture shops with differing design and construction techniques, but training practices and consumer preferences limited variation. As important, only a few carvers worked in each city, so carving is a key indicator of a particular regional style. Ball-and-claw feet, although a minor detail, thus enable us to cluster furniture-makers into urban groups.

Three card tables, all made between 1755 and 1775, in Newport, Boston, and Philadelphia demonstrate these local practices. Card tables made in Newport were distinctive compared to those made in other urban places: the one shown in catalogue 21 has blocked and recessed front areas of its front rails similar to the center tablet and friezes of chimney pieces. Its cabriole legs have angular knees, rear pad feet that rested on small disks rather than the floor, and semidetached talons (figure 4). The Charlestown, Massachusetts example attributed to Benjamin Frothingham (catalogue 20) is notable for the remarkable original needlework on its playing surface (figure 5). It too shows architectural qualities, but a drawer in the front rail breaks up the planar surface. Its ball-and-claw feet are rounded and have two talons sharply raked back. Card tables with rounded corners and deep rails were popular in Philadelphia. The Philadelphia table in catalogue 22, probably owned by Philadelphia merchant Thomas Willing, is profusely carved across the rails and has rounded corners, with ball-and-claw feet that are slightly flattened with sculptural talons and wide webs. As important for the regional identification is the carving that cascades across the rounded corners (figure 6). As a general rule, Philadelphia furniture of the revolutionary generation is often more highly carved than that of many other cities. London-trained immigrants arriving in Philadelphia after 1750 brought the newest styles and highly developed skills and were welcomed by a wealthy population that embraced stylized rococo carving.

How quickly a furniture style changed in a particular place is one index to open cosmopolitan attitudes expressed in new ideas. Furniture production changed little in more isolated societies defined by ethnic affiliation and in small pockets of local preference in smaller towns and rural areas. For example, in western Massachusetts material evidence suggests a society that looked inward; from 1680 to 1740, nearly 250 remarkably similar chests with drawers, chests of drawers, cupboards, boxes, and tables were produced there that are extant. The most common form, dubbed the Hadley chest early in this century for the town where they were first identified, is puzzling because it remained the same for so long, whereas other forms were constantly changing. The tulip-and-leaf design expressed in this chest at Chipstone (figure 7) is one dis-

tinguishing element of these designs. As Boston leaped forward in the 1730s, rural artisans in Massachusetts were ending sixty years of relatively little change. The solution to this mystery brings the maker and the user together in a complex story. One man, William Pynchon (1590–1662), held enough land and wealth to dominate Springfield, Massachusetts, the town that he founded, and several outlying towns by the middle of the seventeenth century. William and his son sponsored numerous public projects and, at one time or another, employed many of the area joiners. Such shared patronage gave a certain impetus to shared forms and techniques. In addition, the isolation of the region along with the tight family ties of local woodworkers led to standardized shop practices and a local sense of what was beautiful—what was attractive in an appropriate form. Finally, it is to the form itself that the story turns. Many of these chests were probably made as dower chests, to hold and transport the sets of household linens and other goods made by young women in preparation for setting up a new household at marriage. Because of this celebratory ritual function, more traditional forms were perhaps valued.[5]

Thus, the idea of a single style that links the way things look to a particular time is riddled with contradictions. The Dunlap chair (see catalogue 6), for instance, was made in New Hampshire between 1770 and 1790 but shares few design elements with contemporary chairs. A Philadelphia chair of high rococo decorative style (see catalogue 5) was made around the same period. Although dissimilar, each was considered attractive to its maker and owner.

A second complication in understanding local interpretations of aesthetics is that design impulses from abroad were not uniform. Even following the styles of England meant selecting forms and motifs from various sources. More variety is evident by the middle of the eighteenth century, exemplified by popular ceramic forms and designs. Fascination with the exotica of East Asia led to the popularity of Chinese-derived or inspired decorative elements. Other influ-

ences evident on decorative objects are the more visible classical world, such as the newly excavated site of Pompeii, and the Enlightenment interest in the scientific classifications of flora and fauna. A consumer could choose a ceramic decorated with flowers (see catalogue 66) or fossils (figure 8) or shaped like a pineapple with a fanciful serpent handle (figure 9). As often, they might select western forms decorated with Asian motifs, such as the cream jug adorned with a "foo dog" (a western misnomer based on a Chinese lion called a *shih-tzu*) or a brown stoneware mug made by the English potter John Dwight in a German form enameled with Chinese figures (figure 10).

This mixing and borrowing of design elements from different cultures is articulated clearly in printed design sources. Thomas Chippendale's *The Gentleman and Cabinet-maker's Director*, first published in 1754, is probably the most famous design source of the eighteenth century, giving rise, of course, to the term "Chippendale style." The book recorded prevalent styles as much as proposing new ones and presents a cornucopia of styles based on different motifs and ornaments—some in the "French style," others in the "Gothic" style, both understood by contemporaries to mean the "modern," more rococo style, blending with the classical past. Others were called the "Chinese" style. Furniture-makers rarely copied these designs directly. The back and front legs of a Philadelphia chair made around 1765 (figure 11) is clearly copied from Plate 14 in the 1762 edition of the *Director*. More often, artisans took bits and pieces from these designs and recombined them in new ways. The maker of the Philadelphia chest-on-chest working between 1765 and 1775 (figure 12) may have taken the finials from a plate of the *Director* even though it matches no complete design.

Ultimately, a decorative arts object is attractive for many reasons. When decorative arts scholars speak of an object's style, they are summarizing a complex blending of cultures expressed in aesthetics and craft techniques that both unify and distinguish groups of people in a particular place and time.

Figure 7.
Detail of Hadley chest (cat. 31)

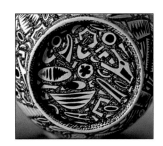

Figure 8.
Detail of teapot with fossil design (cat. 67)

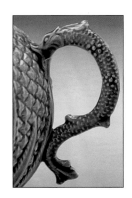

Figure 9.
Detail of teapot in pineapple shape (cat. 68)

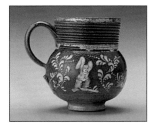

Figure 10.
Jug with Chinese figures (cat. 62)

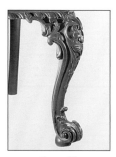

Figure 11
Detail of Philadelphia
side chair (cat. 12)

Figure 12.
Detail of Philadelphia
chest-on-chest (cat. 1)

Figure 13.
Detail of Tinkham
great chair (cat. 4)

Figure 14.
Detail of Boston
side chair (cat. 11)

Commodity

The artisan's success and the patron's pleasure were mediated in another way. In the marketplace, catering to the appropriate market meant that some producers specialized in high-end wares for the most wealthy, others for the less well-to-do. Cabinet-makers' account books demonstrate that the prices of furniture were based on separate elements and a patron could choose a la carte. Ornament or carving could be added, better material chosen for an additional cost. Urban furniture-makers might employ several specialists on a contract basis to provide these optional elements.

At the same time, market competition led to a continual striving to find more efficient and better ways to make things—to make them rapidly with consistent results. "Reduction of risk" is one principle in the creation of the decorative arts; chance for error was heightened in freehand carving or painting, for instance. One way to reduce risk was repeated motion, making more and more of the same thing led to a rhythm of work that sped production and ensured proper result. A seventeenth-century chair-maker often used sticks or strings with markings where holes should be cut as guides to prevent mistakes. Such a pattern would have been useful on the chair made by Ephraim Tinkham II or his associate (figure 13); it contains holes cut in the wrong places to receive the chair's stretchers. Patterns for cutting and carving sped production as well as prevented mistakes. The carver of a Boston chair from the Chipstone collection used a template of leafy C-scrolls and asymmetrical acanthus secured with two nails. Those shallow nail holes remain on the chair, rare physical evidence of a common production practice of using patterns to produce carving (figure 14).

Ceramics had their own efficiencies. The plasticity of clay was especially suited to producing multiple copies. Molding and stamping allowed more elaborate shaping with less labor and higher success rates (figures 15 and 16; see also catalogue numbers 53 and 60). Decoration evolved from reliance on individual painters to printed designs that ultimately enabled more complex surface scenes. Catalogue 57 is a print of George Washington transferred from paper to ceramic. The net result was a successful art object, shaped in large part by the consumer's pocketbook and the larger market conditions.

The trend toward proto-industrial craft techniques and industries helped transform the objects made and used in early America. The overall business conditions in the colonies evolved to create places of commercial importance that local artisans both helped produce and could utilize. A good example is seen in the commercial development of Boston into the center of furniture-making in the American colonies by the end of the seventeenth century. With fewer agricultural products on which to base its economy, it emerged as a place for manufacturing and shipping. This, in turn, helped create a wealthy mercantile community well connected to clients in the larger Atlantic world. These two economic factors ultimately combined: Boston became the first city of the colonies in fashion and style; its vast production and export soon made it the source of furniture for other colonies. Style became a commodity of measurable worth. Merchant-upholsterers were especially successful, and this group provided the capital for production of chairs on a massive scale.[6]

Leather-bottomed chairs, for example, were so commonly made in Boston that the term "Boston chair" soon became a synonym for "leather chairs." Leather chairs, like cane-bottom couches, were part of the new catalogue of forms of more comfortable seating furniture.[7] The Boston example (see catalogue 24) in the Chipstone collection was probably made between 1700 and 1710.

Boston furniture also exemplifies the finest craft traditions and the ways that new styles were imported and disseminated. Boston merchant William Phillips owned a set of English chairs that provided models for Boston woodworkers to produce a large group of chairs that were not exact copies. In the Chipstone example (figure 17), the carver modified the design to fit his own work practices, cutting out his design of

floral volutes on the back of the chair rather than applying it from another piece of wood. Other examples modeled from the Phillips' chairs modified the design in particular common Boston variations.[8]

In the early eighteenth century Boston cabinetmaking was at the height of fashion and skill. Boston merchant Charles Apthorp (1698–1758) and his wife Grizzell (Eastwick) (1709–1796) owned a set of eight chairs, one of which is in the Chipstone collection (see catalogue 25). Probably purchased from the chairmaker and upholsterer Samuel Grant, the carving is attributed to John Welch (1711–1789), the most important and prolific carver in prerevolutionary Boston. The shell and acanthus leaves on the crest rails are repeated in several painting frames that Welch made for Boston artist John Singleton Copley. These details distinguish these chairs from more standard Boston forms.[9] If Apthorp's chairs are expensive elaborations on standard forms, other chairs were less expensive varieties for export. Catalogue 26 is an example of the kind of Boston chairs, often with simpler carving and of less expensive wood, that were shipped throughout the colonies.

This story of Boston furniture is one of many about furniture-making. It is from that kind of detail, nonetheless, that larger themes emerge. Colonial furniture-makers were both artists and businessmen, providing a range of services and prices and efficiently using the pool of local labor. They filled ships with exports to other places. As we learn about furniture through close examination, we can group craftsmen according to style and technique and resurrect the makers of the furniture.

Social Use

Decorative arts objects were made with an eye to beauty and a hand on the pocketbook. Although all art has a function, furniture, ceramics, and the like were used to perform such tasks as protecting clothing from dirt and insects or pouring hot beverages without burning hands. Prints, although often only decorative, sometimes conveyed cultural and geographic informa-

tion. Even the mundane chamber pots, although decorated, were constructed in a form and size that aided carrying and prevented spilling. A chair that quickly broke was no seat of power. A plate with a glaze that was easily chipped and cut with a knife was no enduring source of aesthetic pleasure. The rare seventeenth-century chamber pot in the Chipstone collection is available only because it cracked during firing and was discarded by the potter in a waste pit (figure 18).

Some ideas of usefulness came from improved product performance from other cultures. One problem for Western artisans arose with the introduction and popularity of Asian lacquer work, known in the Western world as japanning. Western consumers quickly appreciated lacquer because of its lustrous durable surface and its exotic beauty, but Western craftsmen could not copy true lacquer. They devised their own process by building up layers of colored finish to simulate lacquer and decorating the surface with gesso figures and ornaments, metallic paints, and gold leaf. Mirrors with japanned frames were particularly popular because both mirrored glass and frame were superior refractors of light, a property that was increasingly valued in the eighteenth century. Mirrors were imported in large quantities from England by the end of the seventeenth century. The japanned mirror from Chipstone (figure 19) is exceedingly rare because it was not imported but made in Boston between 1700 and 1730.

Lacquered surfaces demonstrate that standards of craft performance evolved alongside ideal properties of utility. Usefulness was, in itself, a social construction that changed markedly in these two centuries. Some new furniture forms were invented. A fire screen (see catalogue 30) to shield the face from the heat of the fire was undoubtedly a welcome development to those seeking warmth without discomfort, but had never before been seen. Other standard furniture forms evolved. Tables were used as generic work surfaces, but recreations such as playing cards or drinking tea demanded more specific kinds of tables.

Figure 15.
Detail of red stoneware teapot (cat. 41)

Figure 16.
Detail of white salt-glazed stoneware plate (cat. 55)

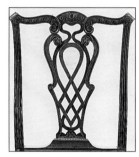

Figure 17.
Detail of Boston side chair (cat. 11)

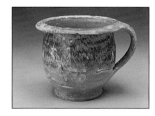

Figure 18.
Detail of chamber pot (cat. 8)

**Figure 19.
Detail of japanned
looking glass (cat. 35)**

**Figure 20.
Detail of work or
sewing table (cat. 88)**

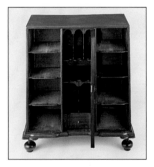

**Figure 21. Document cabinet
(open) (cat. 76)**

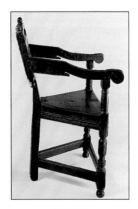

**Figure 22.
Elderkin great chair (cat. 16)**

New furniture forms defined by specific female uses, such as the worktable for sewing and writing shown in figure 20, both reflected and added to an increasing sense of a woman's value as mother and domestic manager in the early nineteenth century. Conversely, the Townsend document cabinet (figure 21) represents a new form that evolved from larger cabinets for the purpose of storing financial records. Like desks, it was part of the masculine realm of increasing business needs in a commercial world. Chairs were more often upholstered for comfort, and for the most wealthy a new form was available and popular by the third quarter of the eighteenth century. The upholstered armchair, such as the Boston example seen in catalogue 90, developed with supportive arms and winged back to provide comfort for those most in need — the elderly, infirm, women before and after childbirth. Finally, following changes in cuisine and manners, ceramics similarly underwent a remarkable specialization of form, from multiuse bowls to specific bowls for dining or tea-drinking.

Artisans needed to solve problems and improve techniques to respond to evolving consumer needs. Craft practices evolved in conjunction with two centuries of developments in social relations, economic patterns, and cultural ideals, all expressed in changing products. What was considered necessary, useful, and desirable tells remarkable stories about the American people who bought and used these objects in their daily lives.

LIVING WITH THE WORLD OF GOODS

If we could enter a seventeenth-century home, we would be entering a world starkly different from our own. Unlike modern domestic arrangements with individual rooms for specific functions, privacy for household members, and a plethora of consumer goods, seventeenth-century styles can be roughly summarized as people living in close proximity and sharing things. This spirit of communal living can first be seen in the paucity of objects owned in any given household. For example, household invento-

ries of the early and mid-seventeenth century show that even the wealthy might own but a single chair reserved for the male head of household. Other family members sat on benches or stools, perhaps even on steps or in doorways, eating from a bowl with a wooden or pewter spoon. The single chair was often called a "great chair." Of the two mid-seventeenth-century chairs in this exhibition, the Tinkham chair (see catalogue 4) represents a common style, and the Elderkin (figure 22) chair an unusual variant, but both are massive constructions with arms for comfort, strong visual symbols of patriarchal authority. Ceramics of the period also show how individual needs were sublimated to a larger unit. Large chargers or platelike dishes (such as the one made by Ralph Toft in catalogue 52) and tygs or communal drinking pots (figure 23) were common products of the era, with fewer individual plates, cups, or knives and forks.

Even in upper-class homes, these furnishings were often placed in one or two rooms where people slept, cooked, ate, worked, and conversed. The fewer objects in a household often had numerous uses. The Mason-Messinger table (figure 24) was a popular kind of table: multipurpose flat surfaces that could be folded and moved where needed. Small trunks or boxes were often all that was needed for storage of the few expensive linens and clothing not in use, although the most well-to-do added cupboards for storage and display.

By the end of the seventeenth century, the increasing wish for individual privacy and personal identity found visual and material expression. New rooms were added to houses that occasionally sported names and dates in their brickwork. Sets of chairs began to replace single ones; sets of plates for individual consumption of food replaced bowls.

Within a half-century, these incipient steps had become a full-fledged gallop. More furniture, more dishes, and more prints filled American homes. High chests of drawers that protected valuable clothing and linens from dirt and insect damage replaced the common box chests of the sev-

enteenth century. The evolution of form and decoration of these storage pieces demonstrates several important aspects of these changes. The six-board chest from New England (1675–1725) was of simple nailed-board construction, decorated with grain painting (figure 25). The chest from Marblehead, Massachusetts (1650–1680) was more expensive and elaborate, featuring joined construction, channel moldings, and simple glyph appliques (see catalogue 74). Both, however, fulfill simple storage needs. In contrast, the Christopher Townsend chest made between 1740 and 1750 (figure 26) does more than protect and organize: it symbolizes a new way of making things and thinking about the world. Its smooth, luminous wood grain reflects a new emphasis on lighting. The top of the chest had special shelves for displaying china figurines, purchased as part of the increasing cosmopolitan interest in the world. Its form was anthropomorphic—it was a human body with high legs, a waist, and decorated head. The Philadelphia chest-on-chest made between 1765 and 1775 (see catalogue 1 and figure 12) is a further evolution. More storage needs helped force out the wasted space of high legs. But the Chipstone chest-on-chest was intensely and completely architectural. It was a building, and like the new town houses around it, expressed a thorough knowledge of classical design and extraordinary skill in carving on the pediment. It was a sign of power, no less than the new public buildings of Philadelphia.

The evolution of these furniture forms expresses much about the eighteenth century. It was not that Americans merely wanted more things, but that they wanted particular new things. Expressing wealth through material possessions was hardly new, but the new consumer goods like teacups expressed important cultural shifts in how social standing was measured and identity was formed. The wish to appear refined—not common, not rude, not loud, not ignorant—is the ideal of moving from nature to culture, from base motives to high ones, from a local world to a cosmopolitan one. In material terms, it meant moving from rough to smooth, coarse to fin-

ished, brown to white. Elements of construction (i.e. , the coarse and natural) should be hidden, whether through the plastering of walls or the blind joinery and smooth veneering in furniture, because refinement was also artificiality.

In social interaction, such changes in attitude led to a heightened exaggeration of politeness, to a more theatrical presentation of self, and to the formation of a material environment to be shared with one's peers in elaborate sociability. Americans of means made the transition from eating to dining, from touching food with their hands to eating with a fork, from cooking stews to making dishes with sauces. They also moved from public rituals of drinking alcohol (with little ability to exclude less worthy companions) to domestic rituals of tea drinking (which valued precise performance of tiny politeness.)[10]

The worldly ethos of the eighteenth century also valued trade and objects from other cultures and found full expression in the phenomenal fascination with products from East Asia. Not only were they decorated with exotic motifs, but goods from those vaguely known places called the Orient demonstrated standards of refinement and skills far in advance of those in Europe. Like lacquer work, porcelain posed a problem for Western artisans. It was a hard, white-bodied and translucent material that surpassed in quality all other ceramics produced by Westerners until the eighteenth century. The Chipstone Chinese porcelain teapot shows that superiority: it was white, thin, delicately painted, and elegant (see catalogue 38). In sum, it was the visual opposite of standard European ceramics that were thickly potted in the colors of clay. More than sixty million pieces of porcelain reached the west from China before 1800. The shock of this new, superior material and its decoration led to a mad "quest for porcelain" by consumers and a century of innovation to try to solve its production mysteries by the pottery industries.

The popularity of foreign goods demonstrated an interest in a world beyond personal experience, a curiosity about other

Figure 23.
Detail of tyg (cat. 59)

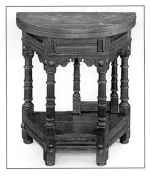

Figure 24.
Mason-Messinger table (folded) (cat. 91)

Figure 25.
Detail of six-board chest (cat. 73)

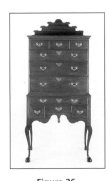

Figure 26.
Townsend high chest with china shelves (cat. 75)

Figure 27.
Print, *Tomo Chachi Mico and Toonanahowi His Nephew*
(cat. 83)

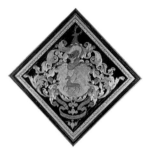

Figure.28
Jabez-Bowen family coat of arms (cat. 10)

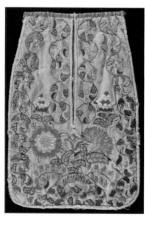

Figure 29.
Women's work pocket (cat. 81)

places and peoples. The maps of North and South America by the Dutch engraver Johannes Janson, printed in 1640 (see catalogue 32 and 33), contained decorative elements of native flora and fauna. Portraits of native Americans were extremely popular in England and America as expressions of other cultures, such as John Faber's mezzotint *Tomo Chachi Mico or King of Yamacraw and Tooanahowi His Nephew*, (figure 27) which commemorated the 1734 visit to London of four representatives of the Iroquois people. Of course, these cultural "others" were modified in varying degrees for European audiences. Nonetheless, the stylized Chinese men and women shown on popular porcelain export wares (such as seen in catalogue 40) were taken to be faithful representations: Robert Southey wrote in 1807 that "the plates and tea-saucers have made us better acquainted with the Chinese than we are any other people."[11]

This rich visual culture of the eighteenth century expanded beyond images of other cultures. Inexpensive printed media and decorated china were extremely popular means of bringing knowledge, color, and beauty to American homes. Their images offered geographical information (maps and townscapes), news (new ships or battle scenes), moral instruction (paths to ruin), and natural instruction (flora and fauna). Each of these themes is illustrated in this exhibition (see catalogue numbers 43 through 51).

Another part of the education of refined people was the acquisition of skills for new leisurely pursuits. Growing in number and spreading geographically after the middle of the eighteenth century, special schools were established for training young women in such accomplished pursuits as music, dancing, and needlework. Fancy needlework was considered a basic accomplishment of a well-to-do young woman, and numerous examples demonstrate the heights of their skills. As in furniture, regional groupings are obvious with needlework, because each teacher taught certain uniform patterns with personalized details added by individual girls. Figure 28 is a Jabez-Bowen family

coat of arms. Made on black silk with silk and gold and silver metals and metallic threads probably between 1780 and 1790, it strongly resembles those made at Boston schools from the 1760s until the end of the eighteenth century. Many wealthy New England families sent their daughters to be educated at noted schools in Boston. The coats of arms in the hatchment (diamond) shape were generally abandoned around 1800.[12]

While the Boston coats of arms were the most richly worked examples of schoolgirl skills, other items were made and embroidered more for daily use. An excellent example is the detachable pocket seen in figure 29. While men's clothing had sewn-in pockets, women's garments did not. Pockets were sewn to hang around the waist on ribbons, partially in view behind slits in skirts, a convenient and private place to keep daily necessities.[13]

These principles of refinement—artificiality, exaggeration, exclusion, exoticism, education, and politeness—can be evaluated by a historical anecdote. When Benjamin Franklin considered a present for his sister Jane Mecom, he at first considered a tea table as a fitting furnishing for a member of his family, then turned to a spinning wheel. To Franklin, a tea table symbolized a life where time was wasted in idle chatter; a spinning wheel signified an efficient housewife.[14] His aphorism in *Poor Richard's Almanack* in 1758 put this concern bluntly: "Many Estates are spent in Getting/Since Women for Tea forsook Spinning and Knitting/and Men for Punch forsook Hewing and Splitting." [15] Franklin was not alone in thinking that tea tables were increasingly required in wealthy homes. After the 1769 marriage of Michael and Miriam Gratz, prominent members of Philadelphia's Jewish community, the couple commissioned a large suite of furniture, including a dressing table, a set of side chairs, and an easy chair, probably to match a high chest purchased some ten years earlier by Michael soon after his arrival from Silesia via London. To provide the appropriate setting for their new household, they also purchased the tea table shown in catalogue 29.

The drinking of tea from porcelain at a tea table may be the essence of refined behavior. Tea was a strikingly distinct commodity from another culture: it was imported and consumed hot and bitter, unlike any known foodstuffs. It came with a host of social accouterments and was served on furniture that grouped social peers in tight proximity for educated conversation and a set of elaborate social behaviors that must be learned and performed with one's social peers. It was an elaborate form of theater in which all were watching to make sure lines were correctly spoken, props were correctly handled, and the stage was correctly set. Knowing how to make and pour tea, handle a cup, converse, even when to go home were all the small signs of being one of us and not like them.

That sense of audience, of self-fashioning, of vanity is one part of the increasing consumerism of the eighteenth century "For what purpose is all the toil and bustle of this world?" asked the British economist Adam Smith in 1757. "From whence, then, arises that emulation which runs through all the different ranks of men, and what are the advantages which we propose by that great purpose of human life which we call bettering our condition? It was to be observed," he concluded "to be attended to, to be taken notice of . . . It is the vanity, not the ease, or the pleasure which interests us." [16] The American John Adams too saw the way that human relations were formed by the material world. He explained carefully that when a man sees another that he considers his equal with a "better coat or hat, a better house or horse, than himself, and sees his neighbors are struck with it, talk of it, and respect him for it . . . he cannot bear it; he must and will be upon a level with him." It was not the hat that caused the desire but the attention that it drew and the respect it endowed upon its wearer. Adams saw this tendency in the microcosm of every neighborhood and in all social classes. Social competition was released where the rich had continually to pull away from those scrambling below. [17]

In a time of seemingly boundless social mobility, people who wanted to rise had carefully to craft a befitting identity of that new status. Most commonly shared was the idea that someone's appearance was an index to social worth. Self-fashioning, vanity, appearances—all were part of the performance. Mirrors became a standard bedroom furnishing (see catalogue 84); and careful grooming needed accessories like rouge pots and basins for shaving (see catalogue numbers 85 and 86).

Fine furnishings mattered because they physically embodied wealth, taste, and style. The competitive urge to display the absolute latest in fashion must have caused fashions to change more rapidly. What surprises us is the speed with which change ensued and the near fanatical wish to be the most in fashion. George Washington had ordered a set of porcelain tableware in 1762, and another in 1763. Yet, even all that porcelain was not enough; in July of 1769 he asked for an assortment of over 250 pieces of Queen's ware "ye. most fashion[ionable]e kind." [18]

By the end of the eighteenth century, changes in the styles of consumer goods were so rapid (and so many people of varied levels of wealth were participating) that we can find the origins of our modern consumer society. Yet only recently has this extraordinary change come to the attention of scholars. Early museum curators noticed the larger number of items to collect and study from the eighteenth century. But the large increase of possessions over two centuries was not truly acknowledged until computer analysis enabled the counting and comparing of household possessions that were documented in household inventories. Many historians have dubbed this phenomenon "the consumer revolution" or the "rise of consumerism" and challenged older economic ideas about the significance of the rise of factory systems of industrialization in the nineteenth century—indeed the more modern world. The debate began with a question: which came first, increasing consumer demand or changed production systems? The controversy continued and addressed complex issues of timing, scale, and motivations for change. We can now say, however, that the notion of economic revolutions has

been replaced with a more nuanced sense of evolving human circumstances, motivations, opportunities, and intellectual ideals.[19]

Nonetheless, untangling those factors is difficult. Greater affordability occurred when more efficient modes of production and more frequent and effective means of transportation met with a rise in disposable income for more of the population. Increased population density meant more consumer demand that could support more retail outlets. Finally, with the idea of desirability, the Pandora's box is opened. People in the past quite simply came to want more and different things. The decorative arts are the kind of commodities that sparked human desire and fueled economic change. In their uses and very materiality lies part of the explanation for the rise of consumer society.

This obsessive spiral did not go unnoticed by contemporaries. While religious complaints against excessive luxury were longstanding, by the middle of the eighteenth century a specific political critique emerged: The debasing effect of too many luxury goods was sapping the American spirit. By the 1760s, political tensions led to American nonimportation agreements, the wish to bring economic force against English manufacturers and merchants, but, at the same time, to halt the spiraling moral decline of consumer excess.

In that heightened political climate, the colonists looked at England as a corrupt empire of luxury and feared the spread of that corruption to their own land. One Virginian blamed that overweening pride and luxury for compelling them to "seek after and desire many Articles which we do not really stand in Need of, and which we cannot afford." [20] The American colonies had become Britain's "goose which lays the golden eggs" by becoming "foolishly fond of their superfluous modes of manufactures."[21] Benjamin Franklin warned the British House of Commons, that those consumer goods were "mere articles of fashion, purchased and consumed, because the fashion in a respected country." When England was no longer respected, English fashions could be easily rejected and the shackles thrown

off.[22] In an anonymous letter in a London newspaper, Franklin wrote of the common resolve that bound the American people: "Let us agree to consume no more of their expensive gewgaws, let us live frugally; and let us industriously manufacture what we can for ourselves."[23]

Thus, by the eve of the American Revolution, the wish to be like England, through copying the latest popular English styles of furniture and importing massive quantities of consumer goods like ceramics, prints, and other household goods, had been transformed. The personal had become political. Refined, fashionable, and worldly English culture had become corrupt and immoral. Americans could only hope to return to a virtuous simplicity by breaking political bonds. A band of rogues dressed as Indians throwing tea into the Boston harbor, now known as the Boston tea party, was a deeply complex piece of theater. It nonetheless symbolized how the world of goods — teacups and tea tables — was more than decorative furnishings. At the same time, artisans were no longer mere makers of things but angry mobs and political figures. Paul Revere was a silversmith and engraver of prints; his 1770 print *The Bloody Massacre*, depicting the Boston Massacre, was enormously popular in the colonies (figure 30). But his fame for us rests not in the things he made, but the things he did, to make this a new nation. That breaking apart is the final story of the dramatic tension to be like England and not like England. A new nation was formed.

CONCLUSION: STORIES TOLD, US AND THEM

Our sense of our national past and identity is based on many concepts, ideals, and myths. Beginning in the generation after the American Revolution and peaking in the colonial revivals of the early twentieth century, Americans have been fascinated with how our nation came to be and a story — not always completely true — emerged to explain who we are. How we think about that past is also colored by the colonial revival houses

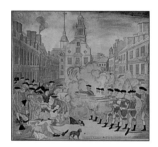

Figure 30.
Bloody Massacre print (cat. 48)

that line city streets and modern furniture marketed in styles vaguely labeled as "Early American." These tables and chairs and chests are interpretations of the goods of seventeenth-century Puritans, later simple "country" or rural peoples, or eighteenth-century patrician founding fathers. Each carries myths and truths, and each is shown in its true form in this exhibition.

The collecting interest of Stanley and Polly Stone is a thus part of that twentieth-century fascination with the past but is simultaneously a way to reappraise it. Two final pieces of furniture in this exhibition help assess how we know and think about the past. The Mason-Messinger table was made about 1650 in New England (see figure 31) . Three hundred and fifty years of use and sunlight have left us a drab brown form decorated with deep carving, fitting furnishings for our modern ideas of the dour and drab Puritan experience. However, decorative arts scholars have shown the richness of life and color in their world. The use of contrasting local and imported West Indies woods, with paint embellishing carved and decorated surfaces, produced a colorful table that was a fitting symbol of a British empire that conquered the world with commercial and military might. It encodes a sense of pride and optimism and is a sign that the new colonies were up-to-date and flourishing.

The New York tea table from the Chipstone collection (figure 32) tells the next century's story. The wars of the British empire at the middle of the eighteenth century brought fortunes to New York merchants and entrepreneurs from privateering and provisioning British forces. New York's population soared and attracted many artisans from abroad. One of these British émigrés was John Brinner, a "Cabinet and Chair-Maker from London" who advertised in the *New-York Mercury* on May 31, 1762:

At the Sign of the Chair, . . . every Article in the Cabinet, Chair-making, Carving, and Gilding Business is executed on the most reasonable Terms, with the utmost neatness and Punctuality. He

carves all sorts of Architectural, Gothic, and Chinese, Chimney Pieces, Glass and Picture Frames, Slab Frames, Gerondoles, Chandeliers, and all kinds of Mouldings and Frontispieces, &c. &c. Desk and Bookcases, Library Book-Cases, Writing and Reading Tables, Commode and Bureau Dressing Tables, Study Tables, China Shelves and Cases, Commode and Plain Chest of Drawers, Gothic and Chinese Chairs; all Sorts of plain or ornamental Chairs, Sofa Beds, Sofa Settees, Couch and easy Chair Frames, all Kinds of Field Bedsteads &tc. &tc.

The listing of his products demonstrates the explosion of specialized goods: for literacy and business (desks and bookcases, tables for writing, reading, and study), for storage (commode and bureau dressing tables), for display (china shelves and cases), for entertaining large parties ("all sorts of plain or ornamental chairs"), for appropriate settings (chimney pieces, frames, mirrors, and chandeliers), and for comfort (easy chairs, sofas, settees). It also tells of competing styles of the mid-eighteenth century (architectural, Gothic, and Chinese). Brinner also noted that he had "brought over from London six Artificers, well skill'd in the above branches."

The multiplication of skills by artisans and the creation of large businesses like Brinner's matched that multiplication of choices for the consumer. While the maker of this tea table is unknown, close study of its form links it to other tables, although a different tradesman carved each. The shop also produced a chimney piece for Van Cortlandt manor house in the Bronx, now considered the height of the American rococo style. At least three of the five carvers in New York during the third quarter of the eighteenth century were British-trained.[24]

Hence, this tea table tells us about the eighteenth century in many ways. It is, in itself, a table for distinctive use. Unlike the seventeenth-century Mason-Messinger table that served several functions, it was purely

Figure 31.
Detail of the Mason-Messinger folding table (cat. 91)

Figure 32.
Detail of New York tea table (cat. 92)

an object of refined towns, houses, and peoples. It was made in a business that relied on multiple specialists to carry out phases of production, such as the hiring of the skills of independent carvers. It shows the continual influx of highly trained and up-to-date craftspeople from abroad that brought the latest methods and styles of making things; the American colonies were no backwater but could support specialists like those in the major English towns. It demonstrates the arrival of specialized immigrant artisans, the influence of pattern books and imported furniture, and local and international economic and political situations.

One final eighteenth-century object completes the story. As much as we discern change, we can find continuity. The harvest jug made about 1748 in Staffordshire, England (figure 33) played a key role at times of ritual celebration for rural communities pooling their labor to bring in agricultural crops. The friends and neighbors who joined together would have been treated to shared drink, served from these large jugs, often decorated with jocular phrases and traditional emblems. The potter decorated this vessel through sgraffito, scratching through a layer of slip to reveal contrasting colors beneath. Decorations include the royal arms with unicorn and lion supporters, the initials "GR" (George II), and the rhyme (laid out to fit the jug's form):

Now I am come for to Supply
your workmen when in harvest dry
when they do Labour hard and Sweat
good drink is better fare then meat
also in Winter when tis cold
I likewise then good drink can hold
both Seasons do the Same require
almost most men do good drink desire

John Hockin
1748

The jug demonstrates the remarkable tenacity of objects of celebration and ritual. Large sgraffito slipware jugs first appeared in the seventeenth century, with the earliest dated form in 1699. The earli-

est of jugs decorated with royal arms was made in 1735, and production of the form continued until the end of the eighteenth century. The vessel type persisted, without decoration, into the nineteenth century. Long after communal entertaining had declined in popularity, and long after the pottery type ceased to be stylish, these jugs continued to be made, used, and enjoyed.[25]

At the end of the twentieth century, we are moving away from many of the polite sociabilities that so deeply concerned our eighteenth-century forebears. Less and less do we gather in dining rooms for formal meals, polite manners, and educated conversations. More and more do we eat with our hands at fast-food venues; we often eat on the go, at unset times and places. Nonetheless, at times of established traditions, we retain vestiges of the social practices and relations that were new to the eighteenth century. Thanksgiving meals, for example, are our own gatherings of friends and family in communal celebration, a time of sharing food and drink (as expressed through the harvest jug), with our own forms of manners, at the dining table with the best dishes and the good knives and forks. The honorific foods we serve at this most American of shared rituals spring from our colonial past, reminding us of our country's beginnings. By retaining these traditions, even as their altered forms reflect our contemporary lives and values, we reenact and commemorate many of their original forms of significance. Through them, we are, in the end, the same as and different from our colonial past.

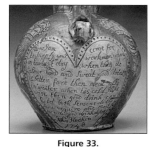

Figure 33.
Detail of harvest jug (cat. 93)

NOTES

1. Benjamin Franklin, "Information to those who Would Remove to America," (Passy, February, 1784), 976, 978 in *Benjamin Franklin: Writings*, ed. J. Leo Lemay (New York: Library of America, 1987), hereafter cited as *Franklin: Writings*.

2. Franklin, ibid,. 976–77.

3. Benno M. Forman, "The Chest of Drawers in America 1635–1760: The Origins of the Joined Chest," *Winterthur Portfolio* 20, no. 1 (Spring 1985): 31–49; Robert F. Trent, "New England Joinery and Turning before 1700," in *New England Begins: The Seventeenth Century*, ed. Jonathan Fairbanks and Robert F. Trent, 3 vols. (Boston: Museum of Fine Arts, 1982), 3:522–24.

4. Trent, "New England Joinery and Turning before 1700," 3:515–19.

5. Philip Zea and Suzanne L. Flynt, *Hadley Chests* (Deerfield, Mass.: Pocumtuck Valley Memorial Association, 1992) ; Laurel Thatcher Ulrich, "Furniture as Social History: Gender, Property, and Memory in the Decorative Arts," *American Furniture* (1995): 52–55.

6. Leigh Keno, Joan Barzilay Freund, and Alan Miller, "The Very Pink of the Mode: Boston Georgian Chairs, Their Export, and Their Influence," *American Furniture* (1996): 267–86.

7. Neil Kamil, "Hidden in Plain Sight: Disappearance and Material Life in Colonial New York," *American Furniture* (1995): 193–96.

8. Luke Beckerdite, "Carving Practices in Eighteenth-Century Boston," in *New England Furniture: Essays in Memory of Benno M. Forman*, ed. Brock Jobe (Boston: Society for the Preservation of New England Antiquities, 1987), 123–35.

9. Keno, Freund, and Miller, "The Very Pink of the Mode," 271–85.

10 Richard L. Bushman, *The Refinement of America: Persons, Houses, Cities* (New York: Knopf, 1992).

11. Robert Southey, *Letters from England*, ed. Jack Simmons (London 1807; reprint, London: The Cresset Press, 1961), 191–92.

12. Betty Ring, *Girlhood Embroidery: American Samplers and Pictorial Needlework, 1650–1850* (New York: Knopf, 1993), 1: 60–75; Betty Ring, *Let Virtue Be a Guide to Thee: Needlework in the Education of Rhode Island Women, 1730–1850* (Providence: Rhode Island Historical Society, 1983), 91–92.

13. Yolanda Van de Krol, "Tye'd About My Middle, Next to My Smock: The Cultural Context of Women's Pockets," (M.A. thesis, University of Delaware, 1994).

14. Franklin to Jane Mecom, January 6, 1726–27 in *The Letters of Benjamin Franklin and Jane Mecom*, ed. Carl van Doren (Princeton: Princeton University Press, 1950), 35.

15. Franklin, *Poor Richard Improved*, 1758 in *Franklin: Writings*, 1298.

16. Emphasis mine. Adam Smith, *The Theory of Moral Sentiments* (London, 1759; reprint, New York: Garland, 1971), 70–71.

17. John Adams, *The Works of John Adams, Second President of the United States*, 6 vols. (Boston: Little and Brown, 1851), 6: 94.

18. Susan Gray Detweiler, *George Washington's Chinaware* (New York: Abrams, 1982), 54.

19. The literature on consumerism in the eighteenth century is growing rapidly and cannot adequately be summarized here. A good place to start is Cary Carson, Ron Hoffman, and Peter J. Albert, eds., *Of Consuming Desires: The Style of Life in the Eighteenth Century* (Charlottesville: University Press of Virginia, 1996); Neil McKendrick, John Brewer, and J. H. Plumb, *The Birth of Consumer Society: The Commercialization of Eighteenth-Century England* (Bloomington: Indiana University Press, 1982). For a summary of the literature on consumerism from the view of the consumer goods, see Ann Smart Martin, "Makers, Buyers, and Users: Consumerism as a Material Culture Framework," *Winterthur Portfolio* 28, no. 2 and 3, (Summer/Autumn 1993): 141–58.

20. "Tillias to Mr. Guy Smith of Bedford County," Purdie and Dixon, *Virginia Gazette*, November 23, 1773.

21. Franklin, "Causes of the American Discontents before 1768," *London Chronicle*, January 7, 1768 in *Franklin: Writings*, 614.

22. Franklin, "The Examination of Doctor Benjamin Franklin, before an August Assembly, relating to the Repeal of the Stamp-Act, &c," February 13, 1766, in *The Papers of Benjamin Franklin*, ed. Leonard W. Labaree et al. (New Haven: Yale University Press, 1969–), 13: 143.

23. Franklin, "Causes of the American Discontents before 1768," *London Chronicle*, January 7, 1768 in *Franklin: Writings*, 615.

24. Luke Beckerdite, "Immigrant Carvers and the Development of the Rococo Style in New York, 1750–70," *American Furniture*: 246–53.

25. Leslie B. Grigsby, *English Slip-Decorated Earthenware at Williamsburg* (Williamsburg, Va.: Colonial Williamsburg Foundation, 1993), 31–37; Leslie B. Grisby, Catalogue of the English Pottery Collection at Chipstone, forthcoming.

CHECKLIST OF THE EXHIBITION

Text by James Bryan, Bolaji Campbell, Catherine Cooney, Robert Cozzolino, Ryan Grover, Diana Sacher, Sherri Shokler, Joann Skrypzak, Gabrielle Warren, and Amy Wendland

As we do today, people in the American colonies and new nation furnished and decorated their homes, entertained their guests with food and drink, and commemorated special occasions. Seventeenth-century American colonists brought with them ideas of Old World styles that were substantially influenced by the mannerist movement and defined by the currents of the Italian Renaissance. This fashion was characterized by rich embellishment that symbolized wealth and worldly exploration and trade. However, there were few such objects in sparsely furnished colonial households. A so-called great chair like the Tinkham example (cat. 4) was often the only chair in a seventeenth-century home. Its straight back, low seat, and high armrests resembling a throne, perfectly represented the place of the male head of household.

By the end of the next century, American houses contained many chairs produced and purchased in matching sets. Elaborately carved, like the rococo Philadelphia side chair (cat. 5), or painted, like that made in rural New Hampshire by the cabinetmaker Major John Dunlap (cat. 6), comfortable and appropriate seating of one's social peers was of greater importance in an eighteenth-century home. The greater diversity seen in the styles of chairs expresses divergence of regions made up of differing ethnic groups and market preferences. Those two simple ideas—more chairs in more households and chairs that showed marked regional distinctions—tell us much about the values, consumer taste, and social behavior of a century of American change. The blending of ethnic groups from Britain and Europe in a new land producing objects for new social practices is one way to understand better the crafting of American culture.

Rich and poor households alike needed pottery to store, cook, and serve their food and drink. Pottery demonstrates changes in style, technology, trade, and diversity, but also expresses our most basic humanity in the rituals of everyday existence. The sgraffito-decorated chamber pot (cat. 8), once common, is a rare museum piece because so few survived. A tin-glazed earthenware food warmer (cat. 7) was highly decorated and expensive, a rare item perhaps used in well-to-do households to keep special foods for the ill.

Increasing interests in matters of taste, refinement, and sophistication led to the transformation of these everyday utilitarian objects into ornately decorated pieces that combine composite design elements. A typical example is a white, conical coffeepot with intricate shell, snake, and floral motifs (cat. 9). The shell motif is also found on the Philadelphia chest-on-chest (cat. 1) and the Dunlap New Hampshire chair (cat. 6) and on other objects in this exhibition. Each artisan combined these elements in different ways for aesthetic pleasure. In all, the decorative arts are inextricably interwoven with the fabric of life in colonial America, a medium through which we can understand the complex culture of early American society.

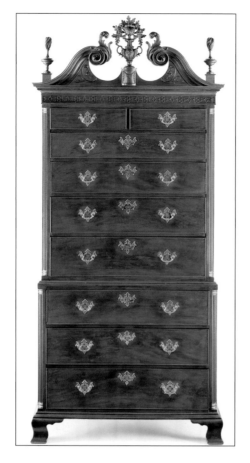

1
Philadelphia Chest-on-Chest,
1765–1775
Mahogany with tulip poplar
and white cedar, 94 $^1/_2$ x 46 $^1/_2$
x 23 $^1/_4$ in.
1996.170

2
Thomas Birch (American,
1779–1851)
*Philadelphia in the State of
Pennsylvania in North America*,
ca. 1800
Engraving, 20 $^7/_8$ x 24 $^3/_8$ in.
1988.2

3
Charles Willson Peale
(American, 1741–1827)
*His Excellency, Benjamin
Franklin*, 1787
Mezzotint, 7 $^1/_2$ x 5 $^7/_8$ in.
1973.3

4
Attributed to Ephraim Tinkham
II (American, 1649–1713) or
associate
Plymouth, Massachusetts Great
Chair, 1680–1700
Maple and ash; traces of origi-
nal red paint, 41 $^5/_8$ x 23 $^1/_2$ x
19 $^1/_4$ in.
1992.4

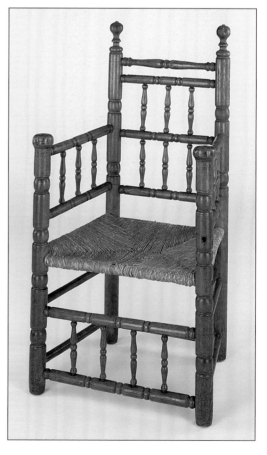

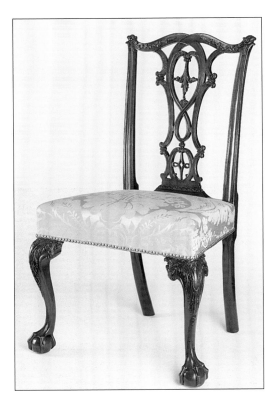

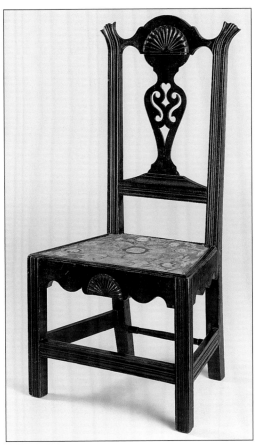

5
Carving possibly by John
Pollard (American, 1740–1787)
Philadelphia Rococo Side Chair,
1765–1775
Mahogany with oak and pine,
38 x 24 x 21 ¹/₄ in.
1961.8

6
Attributed to John Dunlap
(American, 1746–1792)
Goffstown or Bedford, New
Hampshire Side Chair,
1770–1790
Maple, 44 ³/₄ x 21 ³/₄ x 17 ¹/₄ in.
1965.12

7
London Four-Part Food Warmer,
ca. 1770
Buff earthenware, bluish-white
tin glaze, 10 ¹/₄ x 6 ¹/₂ in.
1965.19

8
Donyatt, Somerset Chamber
Pot, ca. 1680–1700
Buff earthenware, lead glaze, 6
¹/₄ x 7 ¹⁵/₁₆ in.
1997.7

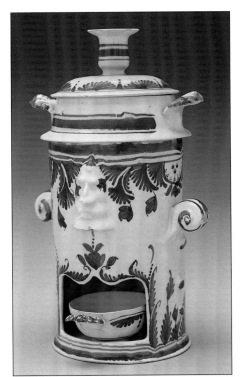

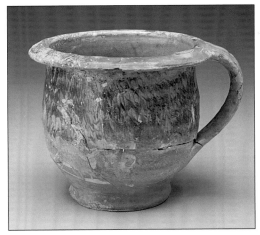

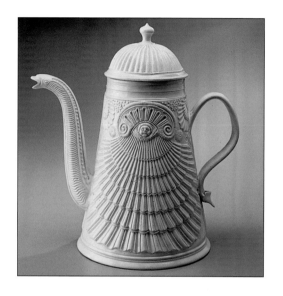

9
Staffordshire Coffeepot,
ca.1755
White stoneware, salt glaze, 9
$^1/_8$ x 5 $^3/_4$ in.
1983.2

AMERICAN MAKERS: ARTISANS
AND THEIR BUSINESS IN A NEW WORLD

The first colonial settlers in America came for such reasons as religious freedom, opportunities in agriculture and trade, and perhaps even for adventure. Among these pioneers were skilled artisans who brought with them their aesthetic, training, and techniques to the New World. The craftsmen quickly adapted to the new environment, fashioning turned chairs and carved chests from the indigenous pine and oak (cats. 14–16). Although their materials generally came from local sources, the sophisticated designs and carvings of their furniture demonstrate how Americans were closely tied to artifacts and institutions left behind in England.

Long after the colonies were well established, English trade policies and cultural affiliations meant that English goods contin-

ued to have a profound influence. Wealthy Americans decorated their homes with family coats-of-arms, often invented (cat. 10). Imported goods and pattern books provided American craftsmen with guides to fashionable living. These cultural linkages are shown in three chairs: the Boston chair was modeled after an imported example (cat. 11), the legs of the Philadelphia chair were an exact copy of an imported design in Thomas Chippendale's *The Gentleman and Cabinet-maker's Director* (cat. 12), and the chair from the Chesapeake region (cat. 13) was made by a recent Irish or English immigrant bringing the latest ideas and methods.

Many settlers came from backgrounds other than British, such as the Germans and Moravians of Pennsylvania or the Dutch of

New York. These and other non-British groups had their own traditions to follow or adapt as seen in the New York leather trunk (cat. 18). Local or regional styles also arose, and each major city developed its own design identity. Particular details such as the carving of a ball-and-claw foot, the outline of a cabriole leg, or specific methods of construction distinguished the products of different cities.. A combination of the varied skills of artisans and local preferences meant that a particular card table could be recognized as following the tastes of Boston, Philadelphia, or Newport (cats. 20–22).

In order to earn a living, makers had to be successful businessmen as well as artisans. It was not enough that a product be attractive, functional, and well made: it had to sell. The rise of Boston as a dominant force in colonial chair production illustrates this notion well. By subcontracting the making of separate parts later assembled into whole chairs, Boston makers came to domi-nate markets from Canada to the Caribbean. Besides becoming more efficient, they also were attentive to differing markets of customers (cats. 24–26).

The same woodcarver might lavish more or less attention to detail depending on the customer. Higher prices for added features, as recorded in cabinetmakers' account books, are demonstrated in a tea table and fire screen, both ornamented by the carving team of Nicholas Bernard and Martin Jugiez of Philadelphia (cat. 29 and 30).

Makers' construction influences also included their customers' expectations and their own training and background, such as the Hadley chest (cat. 31), a type that survived for seventy years with little change. Furniture production exemplified the artisan/client relationship in colonial America. By supplying a commodity that filled both a necessity and a desire for luxury, makers played an important role in the development of America as a consumer society.

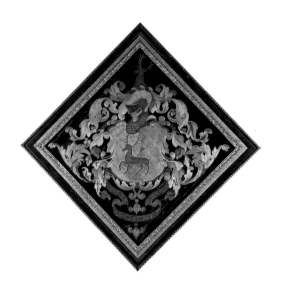

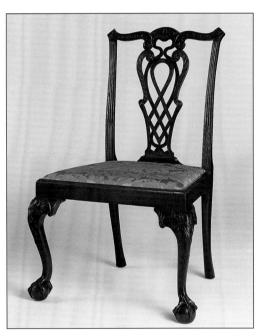

10
Providence, Rhode Island, Jabez-Bowen Family Coat of Arms, ca. 1780–1790
Silk with gold and silver metals and metallic threads, 26 $^3/_8$ x 26 $^3/_8$ in.
1984.11

11
Boston Side Chair, 1760–1770
Mahogany with maple and white pine, 37 $^1/_2$ x 25 $^1/_4$ x 24 in.
1971.3

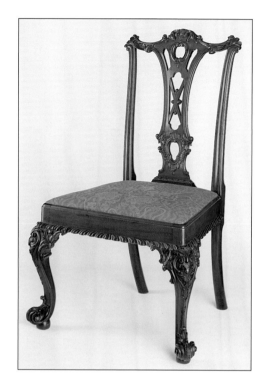

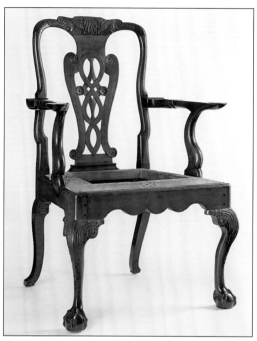

12
Carving attributed to Nicholas
Bernard (American, b. England,
d. after 1783) and
Martin Jugiez (American, b.
England, d. 1815)
Philadelphia Scroll-foot Side
Chair, 1765–1770
Mahogany with pine, 39 1/2 x
25 1/2 x 23 1/2 in.
1990.3

13
Norfolk, Virginia or Edenton,
North Carolina Armchair,
1745–1765
Mahogany; yellow pine slip
seat, 39 1/2 x 25 15/16 x 22 1/2 in.
1997.11

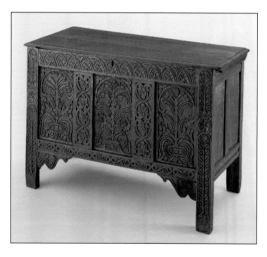

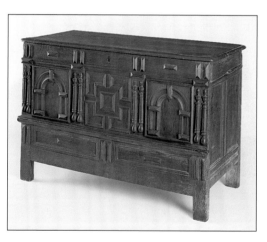

14
Attributed to shop of Thomas
Dennis (American, b. England,
1638–1703)
Ipswich, Massachusetts Carved
Chest, 1665–1700
Oak with oak and pine, 31 3/4
x 49 x 21 1/2 in.
1992.11

15
Attributed to workshop of
Ralph Mason (American, b.
England, 1599–1678/79) and
Henry Messinger (American, b.
England, ?–1681)
Boston Carved Chest,
1660–1680
Oak, Spanish cedar, and walnut
with oak and pine, 30 1/2 x 45 x
20 1/2 in.
1994.9

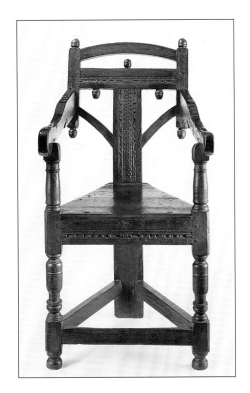

16
Attributed to John Elderkin
(American, b. England,
1616–1687)
Eastern Connecticut, Rhode
Island, or Massachusetts Great
Chair, ca. 1640
Oak, cherry, and ash, 42 1/2 x 22
1/2 x 19 1/4 in.
1992.2

17
Paul Sandby (English,
1725–1809)
*A View of Bethlem, The Great
Moravian Settlement in the
Province of Pennsylvania*, 1761
Hand-colored engraving, 14 1/8
x 29 1/2 in.
1964.12

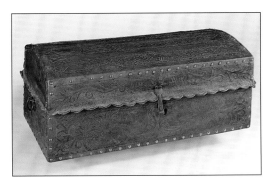

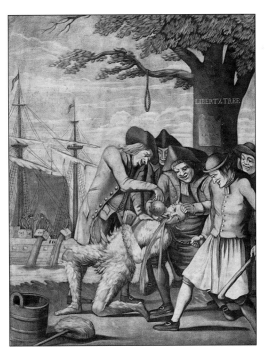

18
New York Trunk, 1740–1780
Gum, leather, nails, wrought-
iron hardware, paper lining, 13
14 x 37 1/2 x 19 in.
1997.17

19
Attributed to Philip Dawe
(English, fl. 1750–1785)
*The Bostonians Paying the
Excise Man or Tarring and
Feathering*, 1774
Mezzotint, 13 5/8 x 9 7/8 in.
1985.11

20
Attributed to Benjamin Frothingham, Jr. (American, 1734–1809)
Charlestown, Massachusetts
Card Table, 1755–1775
Mahogany with maple and pine; original needlework playing surface, 28 $^1/_4$ x 36 $^1/_2$ x 35 $^1/_2$ in.
1972.9

21
Newport Card Table, 1755–1775
Mahogany with maple and white pine, 27 $^1/_2$ x 35 $^1/_2$ x 18 $^1/_2$ in.
1970.15

22
Philadelphia Card Table, ca. 1765
Mahogany with oak, tulip poplar, and white cedar, 29 x 36 x 16 $^3/_4$ in.
1991.4

23
Paul Revere (American, 1735–1818)
A View of the Town of Boston with Several Ships of War in the Harbour, 1774
Hand-colored engraving, 15 $^1/_2$ x 19 in.
1996.3

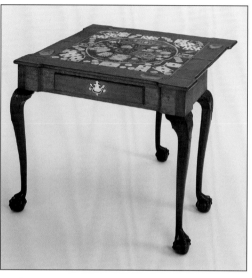

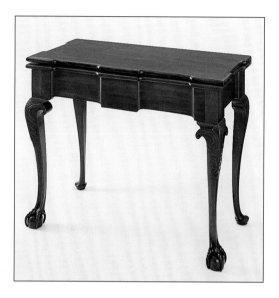

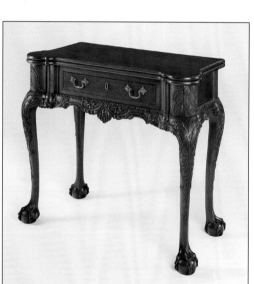

Checklist continued on page 49

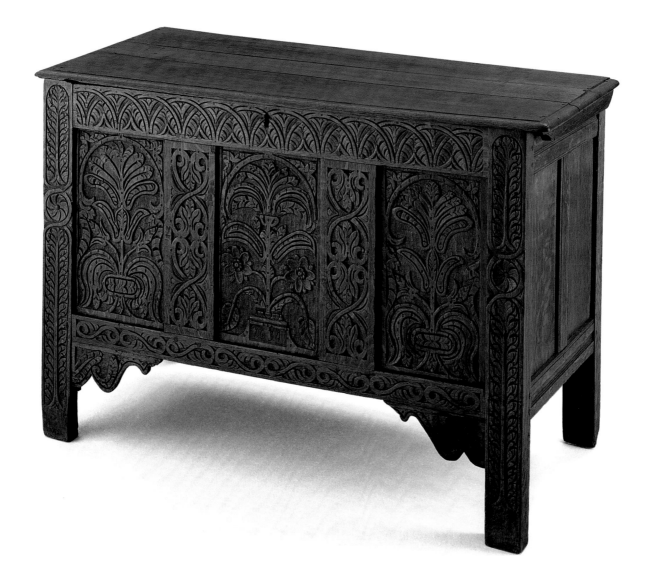

Plate 1 (catalogue 14)
Attributed to shop of Thomas Dennis (American, b. England 1638–1703)
Ipswich, Massachusetts Carved Chest, 1665–1700
Oak with oak and pine, 31 3/4 x 49 x 21 1/2 in.

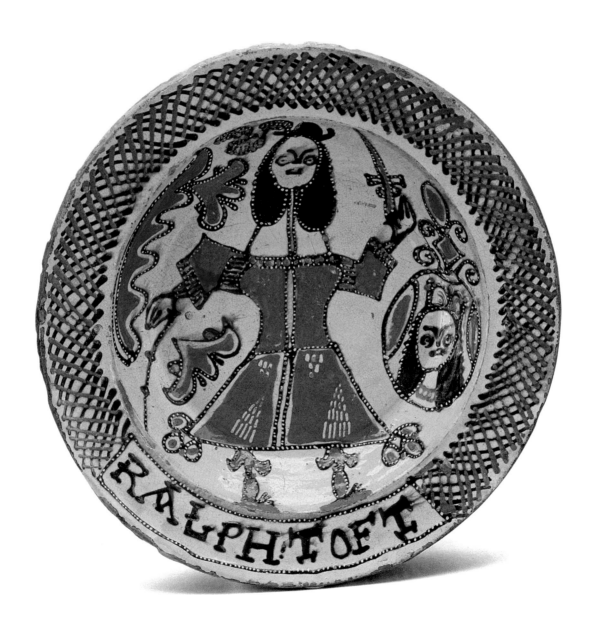

Plate 2 (catalogue 52)
Ralph Toft (British, born ca. 1638)
Staffordshire (possibly Shelton or Hanley) Plate, ca. 1677
Buff earthenware, lead glaze, 3 ¹/₈ x 16 ⁷/₈ in.

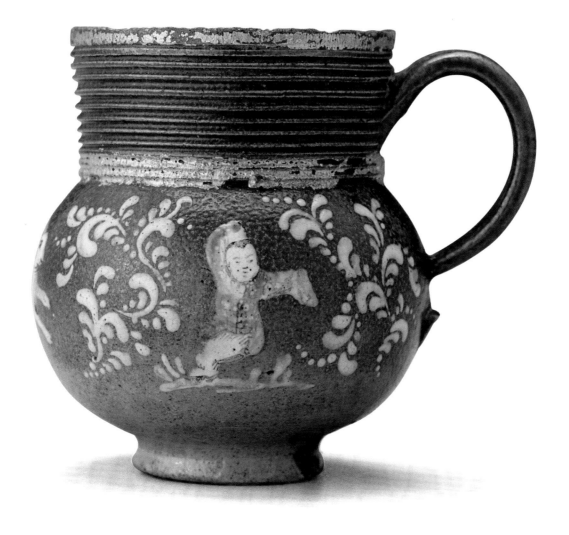

Plate 3 (catalogue 62)
English (probably London) Jug, 1690–1710
Buff stoneware, enamel, gilding, salt glaze, 3 $^1/_8$ x 2 $^7/_8$ in.

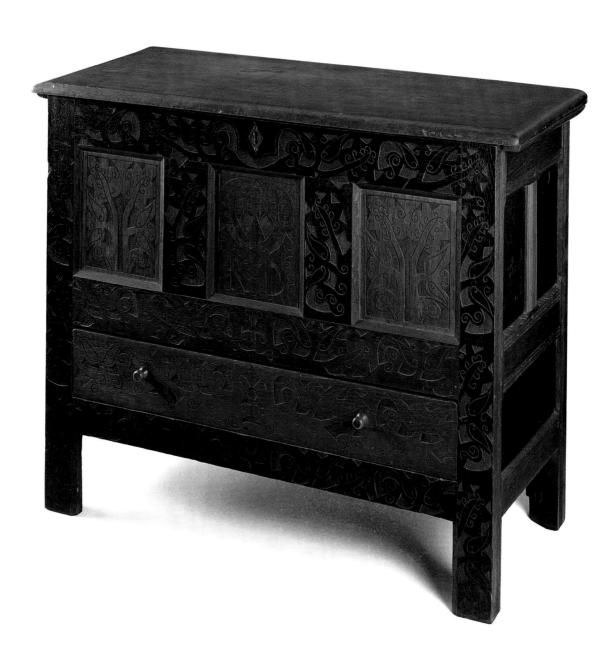

Plate 4 (catalogue 31)
Hadley/ Hatfield, Massachusetts Joined Chest, 1700–1710
Oak with oak and pine, 45 x 36 x 19 ³/₄ in.

Plate 5 (catalogue 44)
Mark Catesby (English, 1679–1749)
Parrot of Paradise, **1731–1734, from the book by Mark Catesby,**
The Natural History of Carolina, Florida, and the Bahama Islands **(London: Catesby, 1734)**
Hand-colored engraving, 13 ³/₄ x 10 ¹/₄ in.

Plate 6 (catalogue 75)
Attributed to Christopher Townsend (American, 1701–1773)
Newport High Chest, 1740–1750
Mahogany with tulip poplar, 83 5/8 x 40 1/4 x 22 1/4 in.

Plate 7 (catalogue 66)
Possibly Aaron Wedgwood (British, fl. 1751–1759) and/or William Littler (British, 1724–1784)
Burslem, Staffordshire Coffeepot, ca. 1750–1765
White stoneware, enamel, salt glaze, 8 ¹/₂ x 4 ⁵/₈ in.

Plate 8 (catalogue 69)
Staffordshire Covered Jug, 1750–1770
Agate earthenware, lead glaze, 5 3/4 x 3 3/8 in.

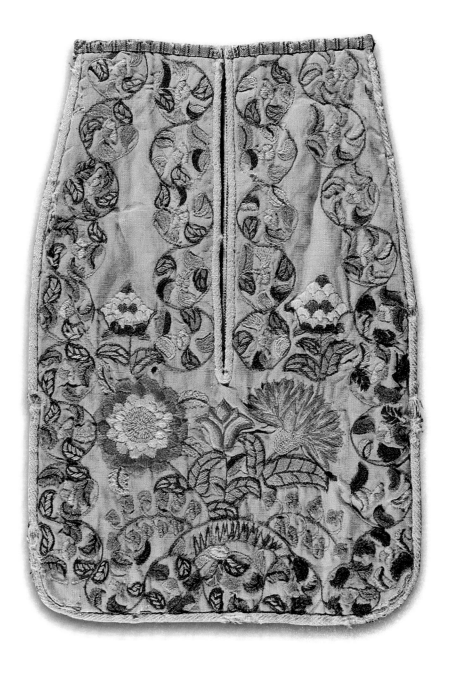

Plate 9 (catalogue 81)
English or American Pocket, 1750–1790
Linen with wool thread (crewel stitch), 12 3/4 x 8 3/4 in.

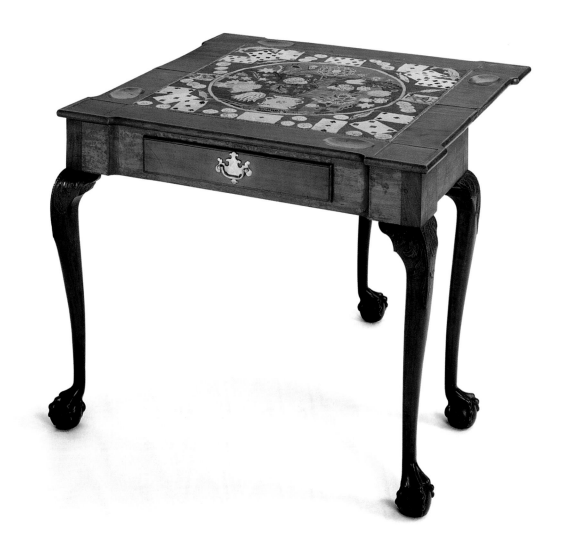

Plate 10 (catalogue 20)
Attributed to Benjamin Frothingham, Jr. (American, 1734–1809)
Charlestown, Massachusetts Card Table, 1755–1775
Mahogany with maple and pine, original needlework playing surface, 28 1/$_4$ x 36 1/$_2$ x 35 1/$_2$ in.

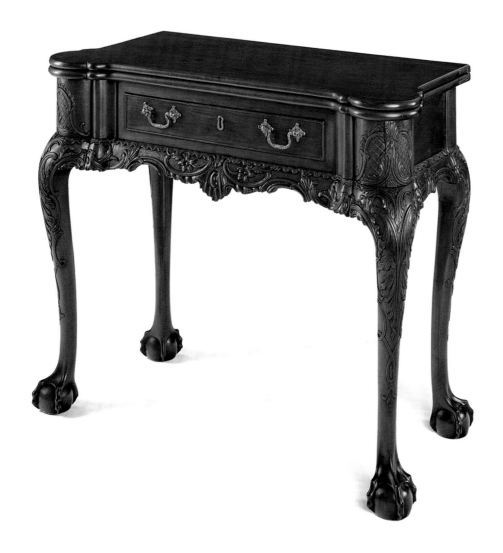

Plate 11 (catalogue 22)
Philadelphia Card Table, ca. 1765
Mahogany with oak, tulip poplar, and white cedar, 29 x 36 x 16 $^3/_4$ in.

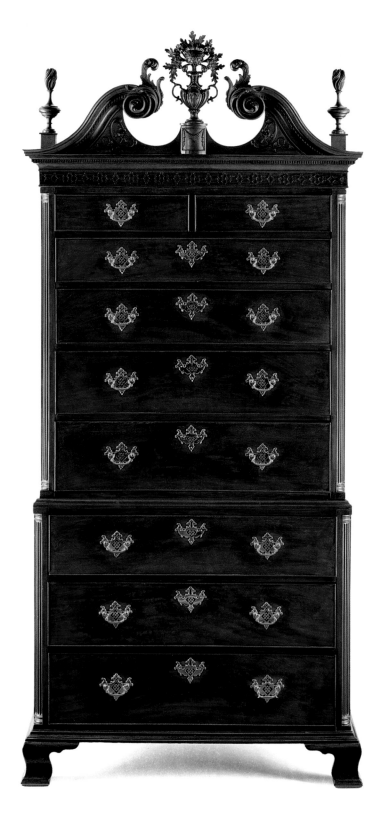

Plate 12 (catalogue 1)
Philadelphia Chest-on-Chest, 1765–1775
Mahogany with tulip poplar and white cedar, 94 ¹/₂ x 46 ¹/₂ x 23 ¹/₄ in.

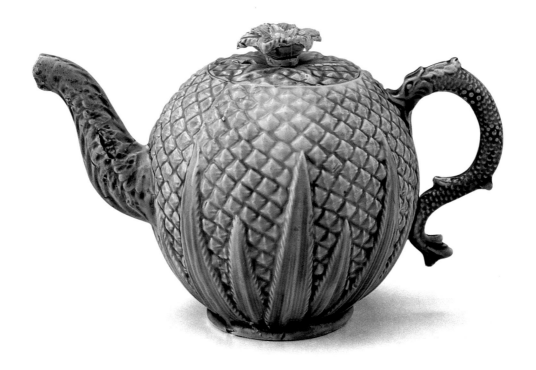

Plate 13 (catalogue 68)
British Teapot, ca. 1770
Cream-colored earthenware, lead glaze, 4 x 6 $^{3}/_{8}$ in.

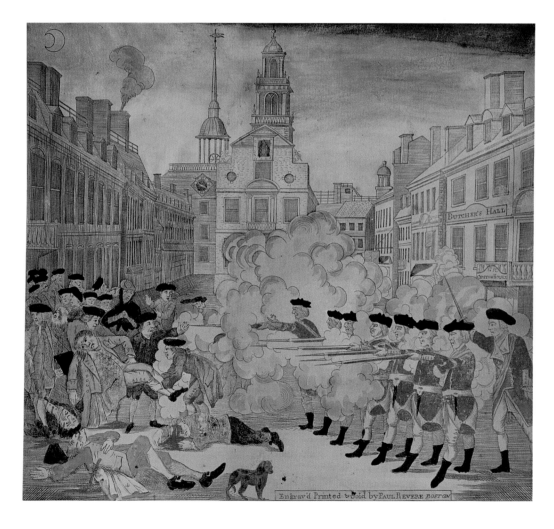

Plate 14 (catalogue 48)
Paul Revere (American, 1735–1818)
The Bloody Massacre Perpetrated in King Street Boston, 1770
Hand-colored engraving, 10 ¹/₄ x 9 in.

Plate 15 (catalogue 6)
Attributed to John Dunlap (American, 1746–1792)
Goffstown or Bedford, New Hampshire Side Chair, 1770–1790
Maple, 44 3/4 x 21 3/4 x 17 1/4 in.

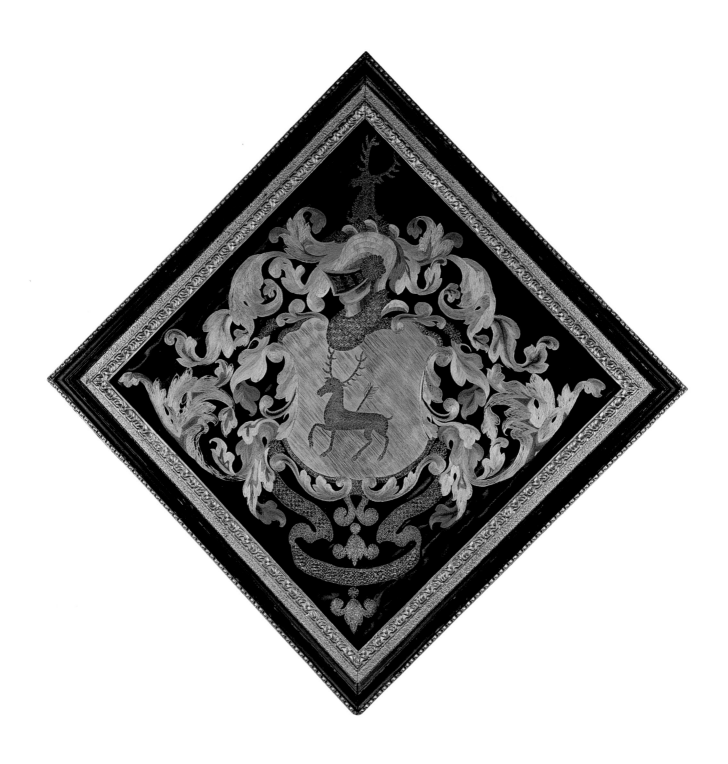

Plate 16 (catalogue 10)
Providence, Rhode Island, Jabez-Bowen Family Coat of Arms, 1780–1790
Silk with gold and silver metals and metallic threads, 26 3/8 x 26 3/8 in.

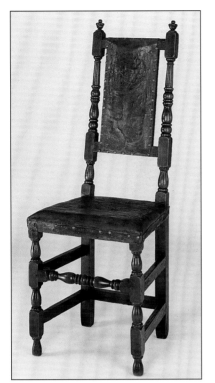

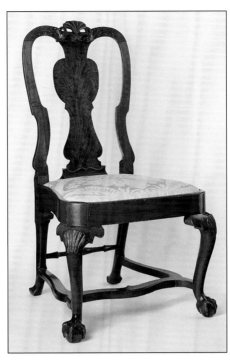

(Continued from page 32.)

24
Probably Boston Leather Chair, 1700–1710
Maple and oak; leather upholstery with wrought-iron and brass nails, 47 3/4 x 18 1/2 x 18 3/4 in.
1992.6

25
Carving attributed to John Welch (American, 1711–1789)
Boston Side Chair, 1735–1740
Walnut and walnut veneer with maple and white pine; maple slip seat, 38 1/2 x 20 3/4 x 18 1/2 in.
1993.2

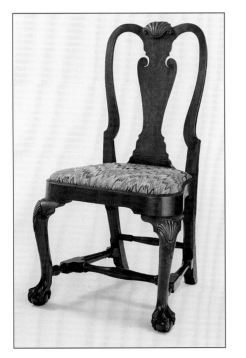

26
Boston Side Chair, 1745–1755
Mahogany; maple slip seat, 38 1/2 x 22 x 21 1/4 in.
1952.9, 1

27
Henry Fletcher (English, fl. 1729), after Pieter Casteels II (Flemish, 1684–1749)
Subscribers, 1730 from a series of floral plates of months, published by John Bowles
Hand-colored etching, 22 5/8 x 17 7/8 in.
1959.10, 13

28
Henry Fletcher (English, fl.
1729), after Pieter Casteels II
(Flemish, 1684–1749)
August, 1730 from a series of
floral plates of months, pub-
lished by John Bowles
Hand-colored etching, 16 ¹/₈ x
12 ¹/₈ in.
1959.10, 8

29
Carving attributed to Nicholas
Bernard (American, b. England,
d. after 1783) and
Martin Jugiez (American, b.
England, d. 1815)
Philadelphia Tea Table,
1765–1775
Mahogany, 28 ³/₈ x 36 in.
1953.4

30
Attributed to Thomas Affleck
(American, b. Scotland,
1740–1795), Nicholas Bernard
(American, b. England, d. after
1783), and Martin Jugiez
(American, b. England, d. 1815)
Philadelphia Fire Screen,
1770–1775
Mahogany with embroidered
panel, 60 ³/₄ x 18 ¹/₄ in.
1990.5

31
Hadley/Hatfield, Massachusetts
Joined Chest, 1700–1710
Oak with oak and pine, 45 x 36
x 19 ³/₄ in.
1988.21

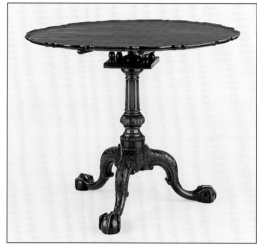

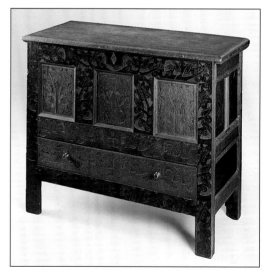

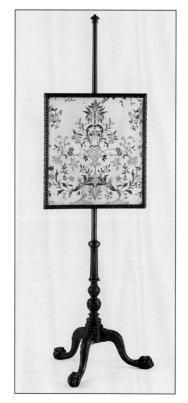

AMERICAN USERS
SOCIAL PRACTICES AND CONSUMER CHOICE

The consumer and the decorative arts in early America intertwine to weave a global, societal, and personal tale. As the Western world expanded its industries and trade routes, new and more specialized wares became available at increasingly affordable prices. The importation of tea, ceramics, and furniture satisfied and fueled a taste for the exotic in both Europe and the colonies. Chinese ceramics, admired for their decorative motifs and technical refinement, were copied, adopted, and integrated by Western artisans for Western audiences. The term "chinoiserie" refers to this Western stylistic development, although the style included decorative characteristics from Japan and India as well as China. As American artisans gained technological sophistication, this absorption of styles from other cultures increased the variety and number of domestic goods (cats. 35–42).

One reason that lightweight, white-bodied, hand-painted Asian porcelains were so popular was that they were so distinct from Western pottery. British ceramics through the end of the seventeenth-century were thrown vessels, embellished with earth-tone colors of yellow, orange, red, and brown such as in the charger by Ralph Toft (cat. 52). Such early ceramics were often decorated by trailing a fine thin clay (a "slip") over the exterior, which, after firing, left a raised relief, often a pictorial design. In contrast, such early eighteenth-century potters as John Simpson developed a method of pressing clay over a mold to create a three-dimensional relief (cat. 53). The practice of using molds increased productivity and allowed for large-scale reproduction for the masses of consumers in both Europe and the New World (cat. 54). A parallel development was mastering the use of such pigments as cobalt to produce the more naturalistic renderings of popular decorative motifs. This desire to reproduce accurately the same images onto the surfaces of large numbers of ceramics led to the invention of transfer-print technology, such as in the image of George Washington on a medallion (cat. 57). Improved British, then American, printing technology and a burgeoning market ultimately led to a far wider visual world for many Americans (cats. 43–51).

Evolving modes of social behavior also required suitable accouterments. Alcoholic beverages, often enjoyed communally in public taverns were challenged by coffee, tea, and sugar—refined new imports enjoyed increasingly by the middle classes in such domestic leisure pursuits as "taking tea." Brewing and serving these new items required special wares, whose own refinement echoed that of the drinks, as well as the social interaction which surrounded them (cats. 58–72).

With greater refinement, specialization, and availability, consumers sometimes chose to have more. By the early eighteenth century, consumers found an increasing need to store their growing collection of possessions. Wooden boxes with hinged lids, like the New England board chest (cat. 73), met the storage needs of most seventeenth-century households. However, the flood of new possessions in the eighteenth century, what historians have dubbed the "new consumerism," necessitated larger and more elaborate storage systems. The production of these refined forms required more sophisticated construction methods, like those found in the Marblehead joined chest (cat. 74). Decorative styles favoring flat surfaces prized for their luster eventually prevailed in forms like the Christopher Townsend chest (cat. 75).

In early America, where social contexts were increasingly diverse and often unfamiliar, clothing, education, and manners helped define one's place in society. Personal objects such as dressing mirrors (cat. 84) and shaving bowls (cat. 86) may represent a means of asserting or revealing one's identity to others.

Although an individual's social and economic position may be communicated

through the kind and number of objects owned, domestic and personal objects also provide clues about the individual's role within the family. Women always managed the domestic environment, but became more significant arbiters of taste by the late eighteenth century. Objects associated with women's domestic roles, such as work tables for sewing and writing (cat. 88) and spice cabinets (cat. 89), display a family's wealth and boast of efficient household management. Other items, such as the needlework picture of Charles I and Henrietta (cat. 87) or the easy chair (cat. 90) mark the stages of life, from girlhood training through marriage and childbirth to infirmity, old age, and death.

Thus, early American consumers both transformed and were transformed by their rapidly changing world. The objects they owned reflect the dramatic interaction of a young nation, its people, and the global community forming during cultural, economic, and industrial expansion in the Western world. Americans adapted and invented an impressive array of decorative arts in which to fashion their identity and shape their everyday lives.

32
Johannes (Jan) Janson (Dutch, 1588–1664)
America Septentrionalis, ca.1640
Hand-colored engraving, gilding, 18 $^3/_8$ x 21 $^3/_4$ in.
1954.11

33
Johannes (Jan) Janson (Dutch, 1588–1664)
America pars Meridionalis, ca.1640
Hand-colored engraving, gilding, 18$^3/_8$ x 21 $^1/_2$ in.
1954.12

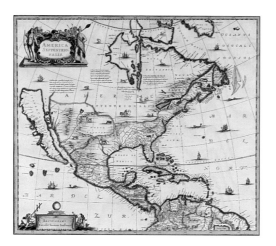

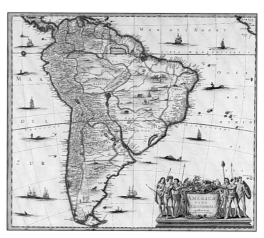

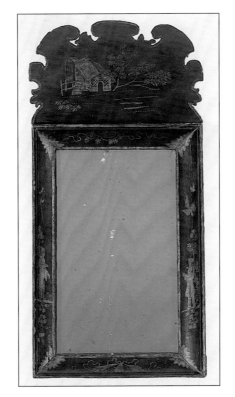

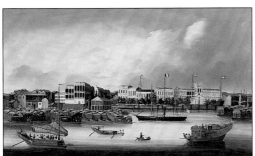

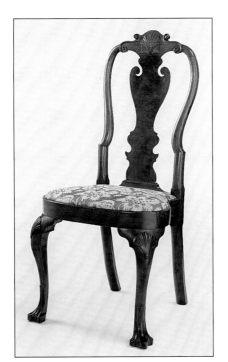

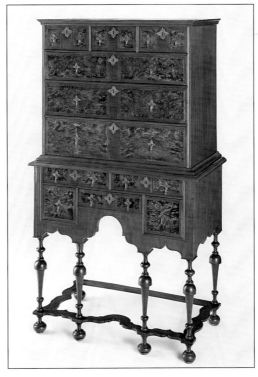

34
Artist unknown
The Hongs at Canton, ca.1840
Oil on paper, 17 1/2 x 30 1/8 in.
1962.14

35
Boston Japanned Looking
Glass, 1700–1730
White pine, 20 3/4 x 10 1/2 in.
1954.6

36
Philadelphia Late Baroque Side
Chair, 1735–1745
Walnut with walnut and pine,
42 1/4 x 20 1/2 x 20 3/4 in.
1973.5

37
Boston High Chest, 1700–1710
Walnut and burl walnut veneer
with white pine, 67 7/8 x 39 15/16
x 22 3/4 in.
1985.12

38
Peking Teapot, 1736–1796
Porcelain, enamel, bronze, 6 x
3 ³/₄ in.
1965.27

39
Three Chinese Snuff Bottles,
mid–18th century
Porcelain, enamel, H. 2 in., H. 2
in., H. 2 ⁵/₁₆ in.
1996.118, 1996.119, 1996.120

40
London Octagonal Plate, ca.
1685
Buff earthenware, bluish-white
tin glaze, ³/₄ x 7 ¹/₄ in.
1984.6

41
Staffordshire Hexagonal
Teapot, ca.1760–1780
Unglazed red stoneware, 3 ⁷/₈ x
3 ¹/₈ in.
1990.11

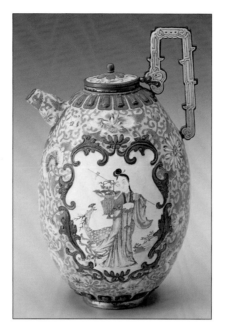

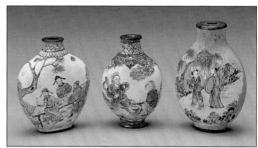

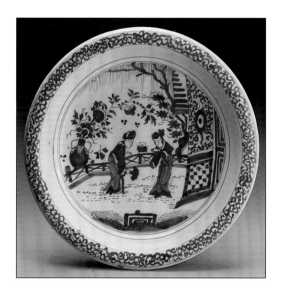

42
English or Netherlandish Bowl
or Basin, ca. 1710
Pale buff earthenware, white
tin glaze, 2 $^3/_8$ x 13 $^5/_8$ in.
1984.5

43
James Hopwood (English,
1752–1819) after Peter
Henderson (English, fl.
1799–1829)
The Quadrangular Passion-
flower, 1806, from the book by
Robert John Thornton, *The*
Temple of Flora (London:
Thornton, 1807)
Color aquatint, 21 $^3/_{16}$ x 16 $^1/_8$ in.
1952.27

44
Mark Catesby (English,
1679–1749)
Parrot of Paradise, 1731–1734,
from the book by Mark
Catesby, *The Natural History of*
Carolina, Florida, and the
Bahama Islands (London:
Catesby, 1734)
Hand-colored engraving, 13 $^3/_4$
x 10 $^1/_4$ in.
1952.36

45
Peter Pelham (American, b.
England, 1697–1751)
Cotton Mather, 1727
Mezzotint, 13 $^3/_4$ x 9 $^7/_8$ in.
1969.12

46
Charles Willson Peale
(American, 1741–1827)
*His Excellency, George
Washington, Esquire*, 1787
Mezzotint, 6 ³/₈ x 5 ⁵/₈ in.
1975.4

47
Nathaniel Coverly, Jr.
(American, ca. 1775–1824)
*The Launch of the Huzza for
the New Seventy-Four*, after
1813
Woodblock and typeset, 10 ⁷/₈
x 9 ³/₈ in.
1971.9

48
Paul Revere (American,
1735–1818)
*The Bloody Massacre
Perpetrated in King Street
Boston*, 1770
Hand-colored engraving, 10 ¹/₄
x 9 in.
1969.7

49
Attributed to Amos Doolittle
(American, 1754–1832)
The Columbus, 1800
Hand-colored engraving, 10 ³/₈
x 13 ⁵/₈ in.
1977.8

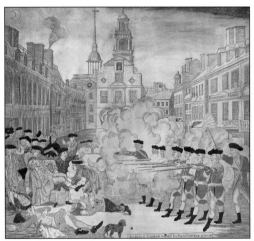

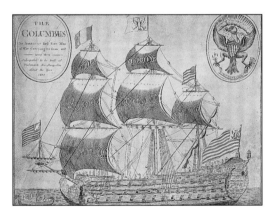

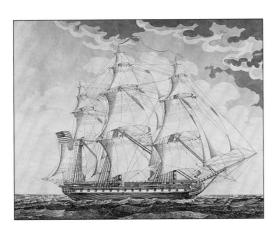

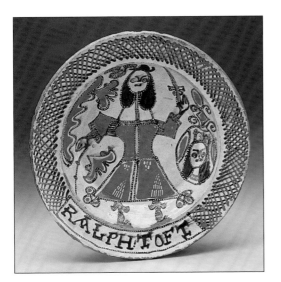

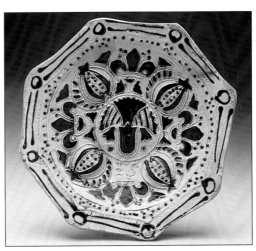

50
William Lynn (fl. ca. 1800–1818)
U.S. Frigate Constitution, of 44 Guns, ca.1813
Hand-colored engraving and aquatint, 17 $^3/_4$ x 22 $^5/_8$ in.
1987.2

51
Amos Doolittle (American, 1754–1832)
The Prodigal Son Reveling with Harlots, 1814
Hand-colored engraving, 14 $^1/_8$ x 10 in.
1991.14,2

52
Ralph Toft (British, born ca. 1638)
Staffordshire (possibly Shelton or Hanley) Dish, ca. 1677
Buff earthenware, lead glaze, 3 $^1/_8$ x 16 $^7/_8$ in.
1993.23

53
Probably John Simpson (British, 1685–1774)
Staffordshire (probably Burslem) Octagonal Dish, ca.1715
Buff earthenware, lead glaze, 2 x 13 $^1/_4$ in.
1993.16

54
English (probably Bristol) Plate, ca.1745
Buff earthenware, bluish-white tin-glaze, 1 $^1/_8$ x 8 $^1/_2$ in.
1992.23

55
Staffordshire Plate, ca.1760
White stoneware, salt glaze, $^7/_8$ x 9 $^1/_8$ in.
1962.9

56
Staffordshire Plate, ca.1765
White stoneware, enameling and salt glaze, 1 x 9 $^1/_8$ in.
1983.14,1

57
British (possibly Liverpool) Plaque, 1799–1805
Transfer print after Gilbert Stuart (American, 1755–1805)
Cream-colored earthenware, lead glaze, transfer printing, 5 $^3/_4$ x 4 $^1/_2$ in.
1998.13

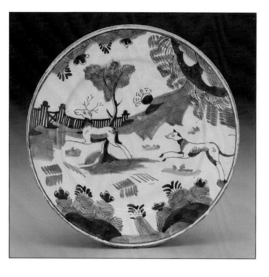

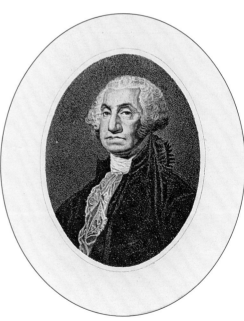

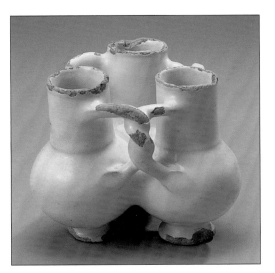

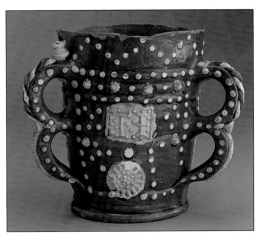

58
London (probably Southwark)
Fuddling Cup, 1635–1650
Buff earthenware, slightly
translucent or pinkish-white tin
glaze, 3 ³/₈ x 4 in.
1991.5

59
Attributed to Thomas Ifield
(British, d.1689)
Wrotham, Kent Tyg, 1649
Red earthenware, lead glaze,
5 ⁷/₈ x 5 in.
1963.15

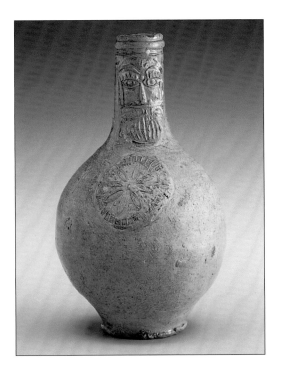

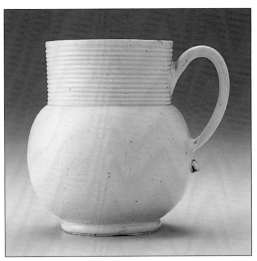

60
German (probably Cologne or
Raeren) Jug, ca.1680–1700
Grayish-buff stoneware, salt
glaze, 8 ¹/₈ x 5 ¹/₈ in.
1964.2

61
Probably John Dwight (British,
ca.1635–1703)
Fulham, Surrey Jug, ca.1685
Brown-speckled white
stoneware, salt glaze, 3 ⁵/₈ x
3 ¹/₄ in.
1994.6

62
English (probably London) Jug,
1690–1710
Buff stoneware, enamel, gild-
ing, salt glaze, 3 ¹/₈ x 2 ⁷/₈ in.
1994.7

63
English (probably Bristol) Puzzle
Jug, 1771
Buff earthenware, bluish-white
tin glaze, 8 ¹/₂ x 5 ¹/₂ in.
1990.7

64
Thomas Rowlandson (English,
1756–1827)
A Kick up at Hazard Table, 1790
Hand-colored engraving, 16 ¹/₄
x 21 ⁵/₈ in.
1964.20

65
English (possibly Sussex,
Somerset, or Nottingham)
Coffeepot, ca. 1755
Red-brown earthenware, lead
glaze, 7 x 4 ¹/₈ in.
1985.6

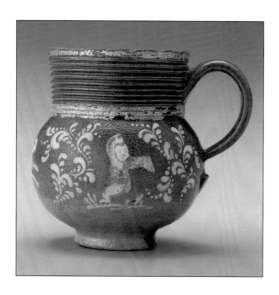

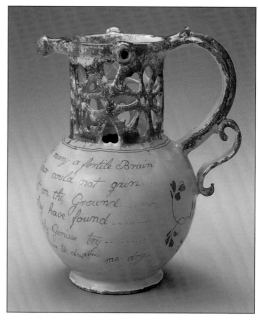

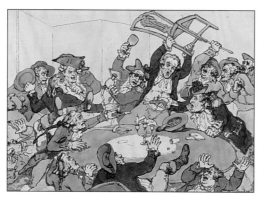

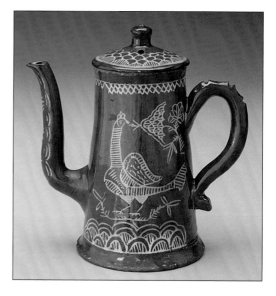

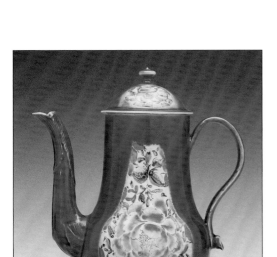

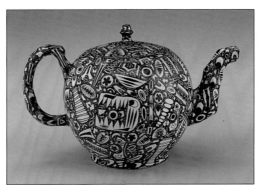

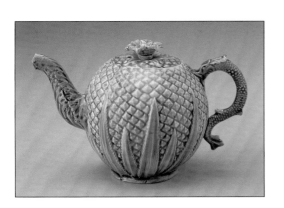

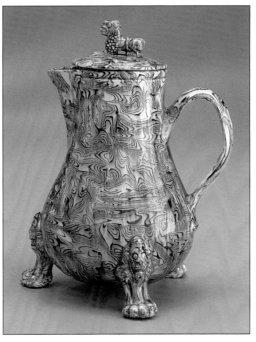

66
Possibly Aaron Wedgwood
(British, fl. 1751–1759) and/or
William Littler (British,
1724–1784)
Burslem, Staffordshire
Coffeepot, ca. 1750–1765
White stoneware, enamel, salt
glaze, 8 $^1/_2$ x 4 $^5/_8$ in.
1983.6

67
Staffordshire Teapot, ca. 1760
White stoneware, enamel, salt
glaze, 4 $^1/_4$ x 4 $^1/_8$ in.
1997.19

68
BritishTeapot, ca. 1770
Cream-colored earthenware,
lead glaze, 4 x 6 $^3/_8$ in.
1997.23

69
Staffordshire Covered Jug,
1750–1770
Agate earthenware, lead glaze,
5 $^3/_4$ x 3 $^3/_8$ in.
1987.5

70
Attributed to William Greatbatch (British, 1735–1813)
Lower Lane Factory
Fenton, Staffordshire Teapot, ca. 1779
Cream-colored earthenware, enamel, lead glaze, 4 $^7/_8$ x 3 $^3/_4$ in.
1996.8

71
English (probably Staffordshire)
Tea Canister, ca. 1765
Cream-colored earthenware, green lead glaze, 4 $^3/_8$ x 3 $^3/_4$ x 2 $^3/_8$ in.
1997.7

72
Staffordshire Sugar Bowl, 1750–1770
Agate earthenware, lead glaze, 4 $^1/_4$ x 3 $^5/_{16}$ in.
1996.169

73
New England Board Chest, 1675–1725
White pine, 23 x 52 $^3/_4$ x 18 $^1/_4$ in.
1997.15

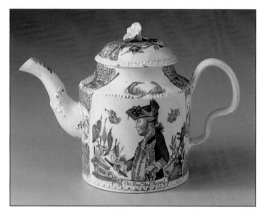

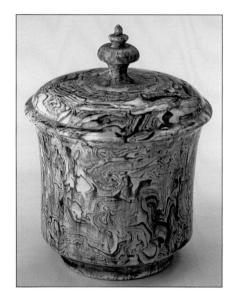

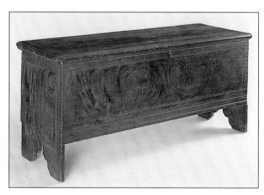

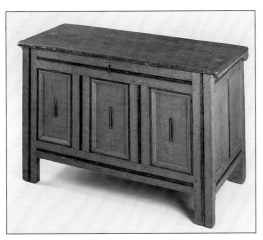

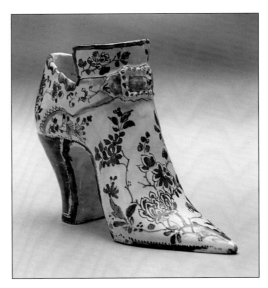

74
Attributed to John Norman, Sr.
(American, b. England
1612–1672) or John Norman, Jr.
(American, 1637–1713)
Manchester or Marblehead,
Massachusetts Joined Chest,
1650–1680
Oak with white pine, 27 $^{3}/_{4}$ x
44 $^{3}/_{4}$ x 20 $^{3}/_{4}$ in.
1950.4

75
Attributed to Christopher
Townsend (American,
1701–1773)
Newport High Chest,
1740–1750
Mahogany with tulip poplar,
83 $^{5}/_{8}$ x 40 $^{1}/_{4}$ x 22 $^{1}/_{4}$ in.
1985.12

76
John Townsend (American,
1707–1787)
Newport Document Cabinet,
1756
Mahogany with white pine,
27 $^{3}/_{4}$ x 25 $^{7}/_{8}$ x 12 $^{7}/_{8}$ in.
1964.4

77
English (probably London) Shoe
Figurine, 1709
Buff earthenware, pale bluish
white tin glaze, 4 $^{1}/_{4}$ x 6 $^{1}/_{4}$ in.
1989.5

78
English (possibly Midlands)
Monkey Figurine, ca. 1750–1800
Buff earthenware, tin glaze,
4 $^1/_2$ x 4 $^1/_8$ in.
1984.3

79
Staffordshire Bear-Baiting Jug,
1720–1770
White stoneware, salt-glaze,
3 $^1/_8$ x 4 $^1/_8$ in.
1970.1

80
Staffordshire Bagpiper Figurine,
ca. 1755
Cream-colored and red earthen-
ware, lead glaze, 6 $^1/_4$ in.
1985.13

81
English or American Pocket,
1750–1790
Linen with wool thread (crewel
stitch), 12 $^3/_4$ x 8 $^3/_4$ in.
1996.113

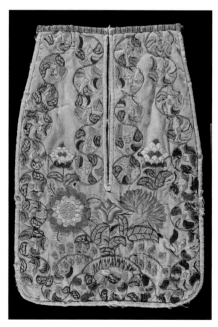

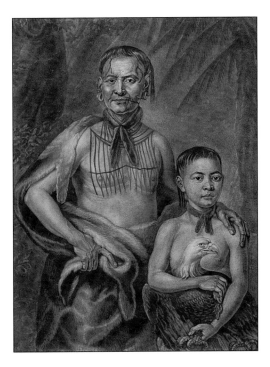

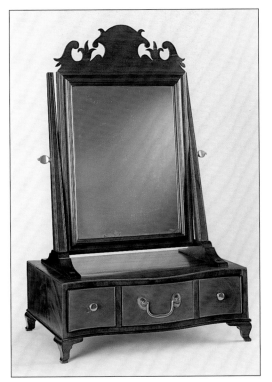

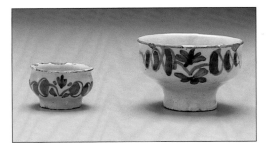

82
William Hogarth (British,
1697–1764)
Characters and Caricatures,
1743
Engraving, 9 $^7/_8$ x 8 in.
1964.38

83
John Faber (British, b. Holland,
1684–1756) after Willem Verelst
(Dutch, d. 1756)
*Tomo Chachi Mico or King of
Yamacraw and Tooanahowi His
Nephew, Son to the
Mico of the Etchitas*, 1734
Mezzotint, 13 $^7/_8$ x 9 $^7/_8$ in.
1989.2

84
Newport Dressing Glass,
1770–1800
Mahogany with chestnut,
poplar, and white pine, 21 x 13
1/16 in.
1976.10

85
English (probably London)
Dispensing Pots, 1760–1790
Darkish-buff earthenware,
bluish-white tin glaze, $^3/_4$ x 1 $^1/_4$
in.; 1 $^3/_8$ x 2 $^1/_8$ in.
1993.12, 1993.13

86
English (possibly London)
Barber's Basin, 1706
Buff earthenware, white tin
glaze, 4 3/8 x 12 1/2 in.
1965.8

87
English, Charles I and Henrietta
Maria Needlework Picture, ca.
1640
Linen canvas with wool, silk,
and metallic threads (tent
stitch), 9 1/8 x 13 3/8 in.
1964.26

88
Boston Work Table, 1790–1800
Mahogany, mahogany and
birch veneers with pine; textile,
28 3/4 x 21 x 17 3/4 in.
1975.12

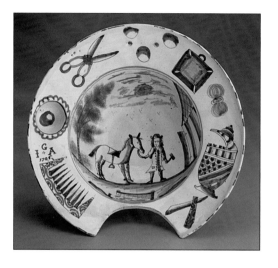

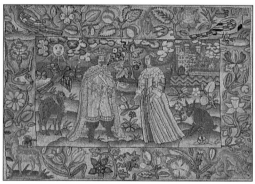

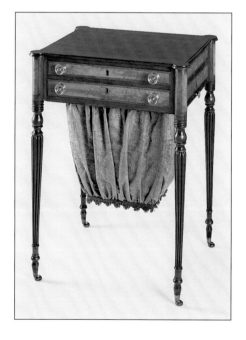

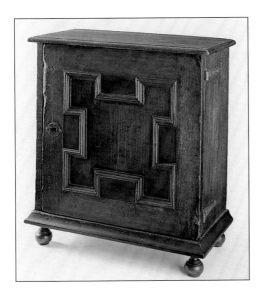

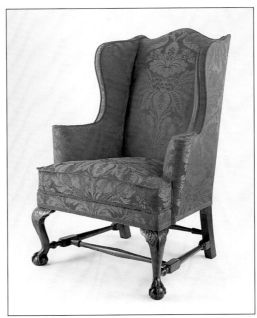

89
Boston Spice Cabinet,
1680–1700
Mahogany and Spanish cedar
with white pine, 18 $\frac{1}{2}$ x 17 $\frac{1}{2}$
x 8 $\frac{7}{8}$ in.
1992.14

90
American (probably
Massachusetts) Easy Chair,
1760–1790
Mahogany and maple with
maple and cotton damask, 45 x
31 in.
1989.8

CONCLUSION

In the century and a half after successful colonial settlement, America underwent massive social, cultural, and economic change. Colonial cities attracted a large and varied population that was continually swelled with many immigrant artisans. Demand for decorative objects brought artisans skilled in the latest European styles and production techniques. A look at the similarities and differences between the folding table from the Mason-Messinger shop of Boston (1650–1670) and the tea table made by the unknown New York artisan (1760 to 1770) reflect many of those changes.

Three hundred and fifty years of use and sunlight have left the Boston folding table (cat. 91) a drab-brown form decorated with deep carving, corresponding to our modern stereotype of a dull and dour Puritan experience. However, decorative arts scholars have drawn attention to the richness of life and color in the colonial world. The use of contrasting woods and paints produced a colorful mannerist-style table of local and imported West Indies woods that was a fitting symbol of a British empire that conquered the world with commercial and military might. It encodes a sense of pride and optimism and is a sign of the new colonies as up-to-date and flourishing.

By the time the New York tea table (cat. 92) was made, rococo had replaced mannerism as the height of style. Moreover, whereas the folding table served multiple functions, the tea table was intended as an object of distinction, of specific usage. It was produced in a business environment that relied on multiple specialists to carry out different phases of production, such as the hiring of the skills of independent carvers. Nonetheless, along with this continuity, the table reflects the trend toward social and technological refinement and the multiplication of forms and choices. The successful craftsperson changed with the times—and changed the times—leading to innovations and producing objects of beauty and utility in a new consumer world.

As much as these two tables express aspects of changing manufacturing practices, the Staffordshire jug (cat. 93) made by John Hockin demonstrates the nature of social interaction in eighteenth-century America, with its role in rural community celebrations.

In looking at our own time, we might ask how such insights into early American practices are different and the same for Americans today. We group socially around tables, sit in chairs, drink from mugs. But too often we cluster around televisions, an action that seem distant from both rural and urban pastimes of earlier America. Twentieth-century technologies have brought us new materials and products but also new problems. While we have grown to expect ever-increasing technological advancement and convenience, we have also grown increasingly aware of the deleterious effects of consumerism. Concern for environmental degradation has led many to reassess values of consumption and spawned programs for recycling and reprocessing. Just as the objects in this exhibition reflect the intricacies of the cultural, social, and personal identities and values of early Americans, so too do our contemporary objects speak of our complex society and era.

Then, as now, the decorative objects that furnish our houses and tables are valued and admired for certain qualities, while other aspects of their significance often go unnoticed. They nevertheless have the capacity to reveal stories about the utilitarian, aesthetic, social, and even political tasks we have asked them to perform, from the earliest stages of their design and conception to the moment they are exchanged as worn-out or outmoded.

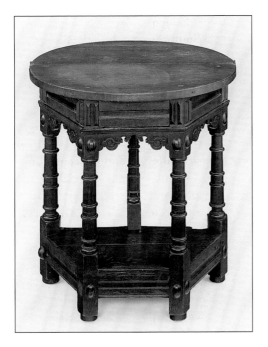

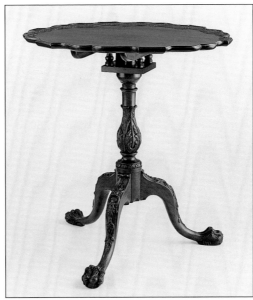

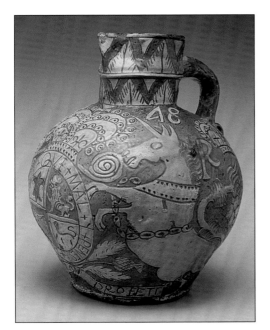

91
After workshop of Ralph
Mason (American, b. England,
1599–1678/79) and Henry
Messinger
(American, b. England, ?- 1681)
Boston Folding Table,
1650–1680
Oak, black walnut, Spanish
cedar, and ebonized maple with
pine, 28 1/2 x 28 3/4 in.
1991.16

92
New York City Tea Table,
1760–1770
Mahogany, 29 x 29 in.
1968.1

93
John Hockin (British)
Barnstaple or Bideford, North
Devon Harvest Jug, 1748
Pale reddish-brown earthen-
ware, lead glaze, 12 1/8 x 10 3/8
in.
1994.10

INDEX

Edited by Patricia Powell
Designed by Earl J. Madden
Produced by UW–Madison Office of Publications
Printed by Ries Graphics, Butler, Wisconsin